T0005376

An Indigo Summer

An Indigo Summer

Ellie Evelyn Orrell

2022

For Clive Orrell

www.uwp.co.uk

British Library Cataloguing-in-Publication Data
A catalogue record for this book is available from the British Library.

ISBN: 978-1-91527-907-1

The right of Ellie Evelyn Orrell to be identified as author of this work has been asserted in accordance with sections 77 and 79 of the Copyright, Designs and Patents Act 1988.

Cover and internal illlustrations © Ellie Evelyn Orrell, 2022
Cover design by Andy Ward
Typeset by Agnes Graves
Printed by CPI Antony Rowe, Melksham, United Kingdom

The publisher acknowledges the financial support of the Books Council of Wales

Arrival

Not conscious
 that you have been seeking
 suddenly
 you come upon it

the village in the Welsh hills
 dust free
 with no road out
but the one you came in by.

 A bird chimes
 from a green tree
the hour that is no hour
 you know. The river dawdles
to hold a mirror for you
where you may see yourself
 as you are, a traveller
 with the moon's halo
 above him, whom has arrived
 after long journeying where he
 began, catching this
 one truth by surprise
that there is everything to look forward to.

R. S. Thomas

Contents

Chapter 1

Returning Home

The journey down is long and aching. It always takes an entire day to trace the familiar route of buses, trains and car journeys southward from the East Neuk of Fife, down into Gwynedd at the heart of North Wales. The train winds through pantile-roof towns towards Edinburgh, before slowing to a steady roll beneath the shadow of the castle, high up on its craggy mount. I watch the blurred landscape through a series of windows, semi-consciously witnessing its steady transformation from sandstone buildings into flat, rambling fields then steep, forested inclines. Beyond East Lothian, the dark green slopes of the borderlands harbouring pockets of windfarms gradually morph into pale, lowline towns. Once the hills flatten out, I know we're moving into England, where a car will collect me from the border and carry me home to the Welsh hillside on which I was raised.

The summer always begins in transit, that necessary peripheral time between endings and beginnings. I'm aware of this feeling as I am carried towards it, towards my mother who has herself just returned from Japan. There is a kind of travel sickness that spreads itself between me and the next few months – a murmuring unease made more palpable by the wobble of the train carriage. It whispers of the uncertainty surrounding how my life will look in the weeks to come.

My mother is an artist. A trait – quality, career, blessing – she passed on to both myself and my sister. Her work has always been attentively concerned with the everyday and the familiar. She spent the years of our childhoods drawing and re-drawing the lines, shapes and shadows of household objects in minute detail and must have made hundreds – perhaps thousands – of drawings observing the shapes of salad spinners, vegetable brushes and wire whisks. Her sculptural works in my teenage years echoed these kitchen utensil drawings using wax and wire. She began to incorporate textiles into her work following the death of her grand-mother in 2010, embroidering stories passed on in the final years of her life onto objects she'd left behind: an ironing board; table cloth; handkerchief. Unknowingly, in doing this, she had been practising a time-old tradi-tion of stitching one's grief into cloth. Just as American

mourners had embroidered images in silk following the death of George Washington in 1799 and Victorian women stitched intricate brooches in their grief, she was making in order to process life's events.

There is undeniably something about careful, practical work that can momentarily lessen the weight of a loved one's absence and yet, the death of her father had proven impossible to heal in the same manner. So, she made a pilgrimage to an indigo farm in Japan in search of a new language of making with which to process this loss.

———— ◆ ————

It was not the first time my mother had journeyed to Japan, though it had been the first since I had been born. On her graduation from Camberwell College of Art in the 1980s, she'd travelled there alone and spent six months immersed in the low wooden suburbs of Tokyo, teaching English in order to support herself. Her most recent eastward journey had been funded by an Arts Council of Wales grant, and she had spent the late spring learning to dye at an indigo farm in the foothills of Mount Fuji.

I shuffle my train tickets as I consider how long it had been since we'd last spoken. Beyond the handful of texts we'd exchanged arranging my arrival, our contact

in recent months had been sparse due to its heavy reliance on internet access and the convenient alignment of time zones, two things that somehow seemed infinitely difficult to orchestrate. Because of this, indigo itself has remained largely unfamiliar to me, I know it only as the dark bruises a pair of new jeans once left along my thighs.

Prior to these quiet months, we'd spoken almost daily. However, in the silence we had independently been trying to find our footing in a world without my grandfather. I had embarked on knitting a long, heavy scarf in rough black Shetland wool, now folded carefully into the bottom of one of the bags on the seat next to me. Meanwhile, my mum had been learning to cloak the world in the deepest blue. We were understanding and coming to terms with the loss in the only way we could – through making.

———◆———

The train speeds past lonely farmhouses residing on murky grey land at the outskirts of Wigan and Preston. Across the bleak pasture, a handful of dairy cows are grazing. Despite the charmless visual of the scene, there is always something nostalgic about these stations as their names are called out over the crackling tannoy. I was born here, in a hospital somewhere amongst

the incessant sprawl of Wigan, yet the industrial landscapes of northern England have always remained unfamiliar. I have mapped them out only insofar as Christmas visits, weddings, christenings and funerals. It's easy to wonder, as the train pulls into Wigan North Western, what it would have been like to grow up on the cobbled backstreets of a town as opposed to the foot-worn lanes that ran along the fields from our house down to the river. Somehow, I can never imagine that I would have ever truly enjoyed it or would have understood the routines of these northern towns. Perhaps I've become too accustomed to the particulars of village life: the intensely quiet dusk, after birds have finished their evening songs; the once-daily buses; knowing every person – at least on a first-name basis – within a five-mile radius; winding roads; wild orchards; crumbling chapels. These things feel like extensions of my being. Recalling them, even in list-form, evokes a homesickness for the patterns of a Welsh life.

Hiraeth. A kind of deeply felt longing to return somewhere. Acting as my compass, the North Star of my wanderings, it is a feeling that brings me home whenever I have been away too long. For me, *hiraeth* is always connected to a desire for the language that drifts between the green hills and settles in the villages of North Wales, where I learnt to speak it. 'The soft consonants / Strange

to the ear'[1] performed a kind of hypnotic effect on me, as a child, when we first moved. In those days, before it had been tamed into vegetable beds and lawn stretches, our garden grew wildly as a thick forest of meadow foxtail and Yorkshire fog. To my five-year-old self it became a fantastical otherworld, in which I would play in a hybrid dialect: part Welsh, part nonsensical sounds that reminded me of it. Over the course of a year in a Welsh primary school, this hybrid play-language quickly evolved into fluency. The lilting rhythm of sentences with their unfamiliar sounds drew me in, and I still feel the same sense of joy whenever I hear or speak the language. Though the more time I spend apart from it, the more sluggish my vocabulary becomes as I find myself occasionally plucking words hesitantly from the far reaches of my memory and hoping that I have chosen the correct one. Or using an accented English word in its place.

Whenever I hear the familiar cadence of the accent elsewhere, I find myself unable to resist asking the question: *'Wyt ti'n siarad Cymraeg?'*[2] with a kind of hushed desperation in my expression – a frantic longing to revive the dormant part of my brain, which exists only in that ancient and poetic vernacular.

1 R. S. Thomas, 'Welsh Landscape', 1952.
2 'Do you speak Welsh?'

———•———

As the train approaches Warrington and my journey its final instalment, I lean against the door to steady myself against the jolt of our arrival. It's getting late, but it's early summer so the sky is still a pale blue smudged with pink. The train comes to a halt and I push the button to release the door, allowing the fresh air to rush in and momentarily revive me.

Standing at the edge of the fiercely demarcated taxi rank, I notice that the contents of my bag, which had felt light enough in the morning, have steadily turned to lead along the journey. Its straps dig tightly into my shoulders as I scan the line of waiting cars. I wait until a familiar tiny silver Peugeot pulls in at the back of the queue; my dad waving to me from the driver's seat.

It has been months since I'd sat in a car. My life in St Andrews that past year had mainly consisted of short walks between the library, halls of residence and a small café where I worked twice a week and spent most of my free moments in meandering conversations over golden espressos and warm croissants wrapped in napkins. In Wales, a car has always felt a necessity. Whenever we were left without one, following breakdowns or general repairs, there was a sense of complete abandonment

of the world beyond the village. Not a feeling that that world altogether ceased to exist, but rather that it was completely beyond our reach. This was a pleasant enough feeling until the milk ran out and the glare of an empty fridge greeted you in the morning. Connection with the urban world was ultimately unavoidable.

The borders of Betws Gwerful Goch are wider than they first appear, encompassing a number of farms, streams, chapels and fields beyond the small cluster of houses at its centre. However, there are no shops, cafés or amenities to be found within walking distance, which meant that throughout my childhood a van driven by a ruddy-faced butcher would appear at the crossroads each Thursday. During the summer holidays, we'd use our pocket money to buy room-temperature cans of lemonade from him. The inside of the van smelled dark and acrid – of meat and old onions wallowing in plastic crates. As a life-long vegetarian, I would stand outside in the square whilst a friend retrieved the drinks and handed over our fifty-pence pieces. On Tuesdays, a baker's van would arrive in its place, selling white loaves twisted into plastic bags and soft, square baps coated in flour.

Their custom came mostly from Betws' elderly residents, who would gather at the crossroads on these days to buy their weekly supplies of meat, a few vegetables, bread and crumpets. All the while, discussing the latest

village gossip with sideways glances to check the person being discussed was out of earshot. More infrequently, a mobile library would appear. I can't recall ever quite knowing when it was coming, though when it did, the occasion always merited an afternoon off from school, as we were filed down the hill into the village to choose a book. These days, people have brown Amazon packages nestled in porches and half-held in letterboxes. The makeshift mobile shops in their reconditioned white vans drive through less and less, increasingly replaced by green Asda vans.

———◆———

I cross the border into Wales with sleep in my eyes. Through curtains of consciousness, I begin to recognise placenames on signs along the A road. The town where I went to secondary school; villages where friends lived; towns where we'd had swimming lessons or doctors' appointments. The June evening dwindles into a dark night and a misty drizzle wraps itself around the car as we move onto smaller roads. Following the old school-bus route home, my mind wanders back to the countless bus journeys I'd made over the course of my teenage years on these winding roads between Ruthin and Betws Gwerful Goch. Desperately reaching

for independence yet too stubborn to spend money on learning to drive, I would organise my social calendar around the exceedingly fickle bus schedule between our village and Ruthin, once walking six miles along this route to a party when the Saturday afternoon bus failed to appear. These memories flicker into the present as we drive past the point where I had met a lithe, roaming sheepdog on that journey, who herded me along a short way by circling my legs and barking sharply.

As we continue to drive along empty roads, a blanket of stars unfolds across the now-indigo sky above. The deep yellow crescent of the moon sits low; partially obscured by the pine forests that mark the road. Beyond the forest, the moonlight cascades onto open fields, tumbling down towards a village. A few stray sheep who have been wandering the night roads catch our headlights with their lamp-like eyes and scatter, their bulbous bodies billowing ahead of the car in panic. Passing the Pendre farm further down the road, we watch as they gallop up the track towards the yard. At the bottom of the hill, we drive through a small village and over a bridge, before turning onto a relatively straight road, which runs through the middle of the valley. At the end of the road, the glimmer of house lights signals that our destination is in sight. As the lights come steadily closer, a wave of relief passes over me: we are almost home.

———•———

It's a strange feeling, to be returning home. I realise that my body has been steadily tensing, worrying that the life I left behind when I went to university would no longer be waiting for me; that my habits, personality and experiences had changed their shapes and no longer fitted into this old way of life. Yet, what I notice as we drive along familiar roads is that this seemingly timeless world I'd left has changed too in my absence. Its transformations becoming glaringly obvious as we pass them on the route home: newly built plastic bus shelters and the unbearable stink of industrial, steel-frame chicken sheds with long, menacing forms regimentally laid out along the fields. An old farmhouse had been demolished, the flattened ground beneath it holding the foundations for a new build. As we turn into the village, our headlights bounce off the reflective curve of plastic now standing in place of the old, stone-built bus shelter.

The changes are unsettling, not only insomuch as they indicate a passing of time, but also in their representation of its speeding up. The slow and steady pace of the rural life that I had grown up with was not quite as unchanging as I'd imagined. It somehow seemed more industrial, more anonymous than I'd remembered. The

waves of travel sickness push against my body once more.

————◆————

The crossroads at the heart of the village are lit by a tall streetlamp that throws a yellow light across a handful of low cottages and an old church surrounded by a graveyard filled with elder and crab apple trees. Concealed within a drystone wall thickened with brambles is St Mary's, a church which sits along the ancient pilgrimage route between Bala and Holywell, and is said to have been founded by Gwerful, a grandchild of King Owain Gwynedd, in the twelfth century. In keeping with this, the village's name, Betws Gwerful Goch, translates to 'the prayer house of Gwerful with the red hair' and her likeness – a smiling face with flowing nylon hair cascading down around a depiction of the stone church beneath – was embroidered onto the burgundy jersey of our primary school jumpers. Although her presence in written history remains vague, she is memorialised in the name of this small community. In this way, the village's name serves as a reminder of the ancient roots of settlements in this valley.

Though we still visit the churchyard to collect apples, blackberries and elderflower, the building itself has long been disused due to a colony of bats making it their home

and preventing a service from taking place without great distress and a good deal of pew-cleaning. The last service I attended there was a harvest festival aged nine, when the swooping bats had provided excellent entertainment for bored schoolchildren stealing glances up to the ceiling during the end-of-service prayer.

———•———

We don't meet any other cars at the crossroads. It is quiet and still. A great silence has spread itself across the village as it generally does with nightfall, interrupted only by the distant bleats of sheep. It's hard to imagine that these are the same crossroads where the artist Augustus John and scholar John Sampson spent their evenings drinking, singing and fighting amongst the Romani traveller folk many years ago. Yet, the hand-shaped door knocker of the corner house serves as a reminder that it was once The Hand pub, frequented by the Welsh–Romani and the artists and writers interested in their language, stories and ways of life. Indeed, for a time, this tiny village became 'the centre of gypsy studies and revelry'.[3] Now however, the two village pubs, which once overflowed

3 Anthony Sampson, *The Scholar Gypsy* (London: John Murray, 1997), p.90.

with gypsies, scholars and farmworkers, are sleeping houses with their curtains drawn. Only two pale slivers of light, which twist their way through breaks between the curtains, indicate any life inside.

Turning left and following the road between the two old pubs, we begin a steady upward climb towards a row of three terraced houses halfway up the hill. Ours is the middle house. A white cottage with four blue windows. The lights downstairs are on and there is a familiar, warm glow being thrown out onto the road beyond. From the car, I can see my mum in the kitchen, wearing a grey crossover apron. The table is laid for a late supper, lit by a stout beeswax candle on a saucer with a thickly sliced spelt loaf on the breadboard beside it. The familiarity of the scene eases my anxieties over having been away for so long.

Inside, the smell of a summer soup fills the small kitchen: a concoction of early summer greens, fennel and herbs from the garden. My mum moves between shelves, cupboards and stove, gathering things to stir into the cast-iron pot, which is sending off a sweet misty steam. Although the house still looks much the same as it had throughout my childhood, our lives outside of it have expanded and changed. We are both in states of readjustment, returning to routines we'd long committed to memory after months spent in less

familiar geographies. My mum arrived home a week earlier, with a suitcase filled with folded indigo and a sketchbook of botanical drawings in dark ink. My own luggage, now settled in the doorway, is bursting with second-hand clothes, a couple of long-term loaned books from the library and a sourdough starter. Our months apart from one another are concluded with an embrace and immediately life in this small Welsh village begins again.

———◆———

When we first moved into the cottage, my parents converted the attic into a studio space. It became a long, narrow room filled mostly with packed boxes, bubble-wrapped frames and miscellaneous collections of natural objects. At one end, a ledge created by the chimney that ran through the house held a line of perfectly rounded sea-worn pebbles. At the other, my dad had pinned a row of tiny bottles suspended by wire loops, each with a drawing inside. My mum's desk had always been a collection-ground for pressed flowers and dried leaves, which she would produce from various books or occasionally from between the bank cards in her wallet as wafer-thin translucent offerings. Two angular skylights flood the space with light and frame

the green fields that stretch out beyond the vegetable beds of our back garden. Postcards, newspaper clippings and childhood drawings proudly presented by my sister and I are affixed to the wooden beams, which run along either side of the room where the sloped ceilings meet the walls. Despite having this studio space, we would arrive home from school each day to find a patchwork of paper and sketchbooks spread out across the dark wood of our kitchen table. The assemblage of finely observed kitchen objects would exist at first as shiny wet lines of oak gall ink and watercolour against old envelopes and sketchbook pages, before drying into the darker, confident lines of her work. Once we were home, she would begin to clear them away whilst asking us about our days at school, gathering the drawings up and storing them in large sketchbooks or folders.

———•◆•———

That evening, a thickly filled sketchbook from her trip sits half-open on the windowsill and I look through it after supper. I recognise the distinctive confidence of her drawings; however, their subject matter has changed. The pages no longer document the domestic and everyday objects of our home but rather a collection of patterns and botanical drawings rendered in their most

elemental forms, abstracted fluidly by her hand. The paper had rippled under the strain of liquid against its thin surface. There is a beautiful simplicity to them, with colour palettes composed from the colours found in her travel-sized watercolour box: indigo blue paired with oxblood, ochre and burnt umber. We both own a small set of these watercolours, procured on a kind of pilgrimage made to Italy the year before. We had been to Florence in search of an art shop, nestled in a narrow street behind the cathedral, where they make water-colours using honey, bringing home a paper bag filled with tiny, colourful pans, which we divided between two travel tins on our return.

As I study the sketchbook, she produces a larger bundle of drawings from beneath a stack of cookbooks on the kitchen sideboard, telling me she'd begun work on these since her return from Japan. Made using indigo tempera paint – also brought back from that Florentine trip – they show a collection of richly painted poppy seed heads. Their spherical shapes pull upwards into elongated blue lines across the page. I leaf through the pages as she tells me that they are preparatory studies for the work she intends to make with indigo. She tells me that she hasn't quite made sense of how they will translate onto cloth yet: that is what the summer is for.

———•◆•———

My plans for the summer ahead do not extend beyond simply being at home. It always feels right to stay put once I have arrived. Perhaps, on some level, that is because it feels so complicated to navigate the journey here, you may as well stay for as long as possible once you've arrived. As it was when Sampson and John lived here in the early twentieth century, Betws Gwerful Goch truly does seem to be located 'at the end of nowhere', and it is a wonderful quality.

The summer before me feels different – a sense of the unknown lingering at its edges. I know little, if anything, about indigo. My understanding of this ancient colour does not extend behind the tiny, honeyed paint pan in my watercolour box. Yet, I have a feeling that its pigment will come to define the entire season ahead.

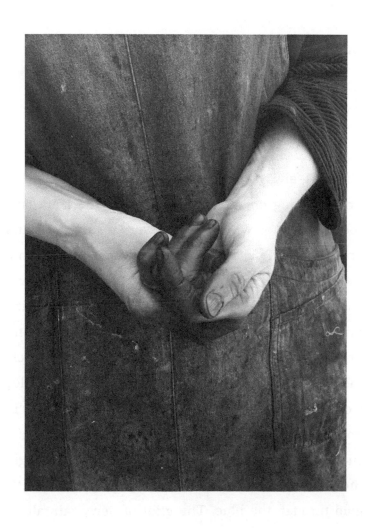

Chapter 2

The Woodshed Vat

There is always something spectacular about that first morning on returning to Wales. The landscape seems saturated with life, and every mossy stone and grass-crackled pavement bursts out to greet you in a way that no city's nature reserve or protected parkland could ever mimic. I am met by a familiar early-morning mist beyond the window of my childhood bedroom. There is a certain way in which it seems to encircle the tops of the forest-covered hills across the valley from our house – I've tried to capture it many times in both photographs and paint, and yet have never quite succeeded with either. If you wake up early enough, the small constellation of streetlamps glow a gentle gold through the blue. The glint of dewy rainfall on the pear tree outside in the garden signals the night-time rain under which I arrived but today, above the mist, is a clear sky. I push down the sash window and

hear blackbirds fill the hillside garden with a bright whistling, which is carried into the room on the cool morning breeze.

Although this view has remained largely unchanged since moving to Wales fourteen years ago, a whole season has passed since I last looked out towards the opposite hill on which my primary school sits, its facade gleaming out against the green playing fields and forest behind like a badge on the chest of the hillside. Above the school, in the spring, there is a field filled with blue-bells. Now, it has been transformed by the summer into a rich green tangle of ferns and brambles. I think of all the times my hair had been caught and eye-wateringly tugged out by these brambles as a child. Growing up seemed to be a constant mess of scrapes, dirt and bruises resulting from a rural upbringing which took place mostly in open fields and muddy rivers.

Downstairs, I can hear the familiar percussion of tea-making signalling the beginning of the day. The clamour of our old aluminium kettle being filled and put on the stove to boil ricochets through the house, an indiscreet call for people to make their way to the kitchen for a *paned*.[4] I make my way downstairs, wearing thick socks despite the season. Our house is made

4 *Paned/Panad* is the Welsh colloquialism for a hot drink.

up of wooden floorboards, except for the kitchen with its burnt orange quarry tiles that are piercingly cold against bare feet in the winter and only slightly less so in the summer. My mum has already set up the indigo vat outside. Still wearing her pyjamas, she prepares breakfast whilst allowing it to settle. I'm informed that once it is ready, a copper film and a blue, flower-like mound of bubbles will appear on the surface of the liquid. We eat sourdough toast with a thick layer of last winter's marmalade for breakfast before going out to check on it.

————•————

The vat has been set up in a deep, blue bucket inside our woodshed, sheltered under the corrugated iron roof in order to protect it from the unpredictability of the Welsh weather. The sandy-coloured wall of logs behind it now shows the faintest blue splatter. Mum removes the black lid from the vat and beneath is a shimmering, petrol-like film with the promised bubbling blue rose at its centre. So began the first day of the summer: early morning, outside in our woodshed, a pale blue sky and the first drops of amber sunlight sliding through the planked walls.

————•————

The woodshed looks out across the valley, with its village nestled between two hills. It is, as John Sampson described it, 'a tiny scattered village which seemed to be hidden by trees and surrounded by hills'.[5] A stream cuts through the middle. At this time of year, it is the perfect paddling depth, though when I was last home, it was a fierce, brown force rushing towards the Afon Alwen and then onto the Dyfrdwy. There were winters when the bridge appeared as an island, divided from the road by a flood of murky water. Others, when it was reduced to a slow trickle beneath a thick layer of ice.

It's the kind of village that I had thought of as being a village until I went to secondary school and was informed by school friends that it was more a collection of houses and fields than a village as such. I can name every inhabitant of every house.

I think about how children at school were referred to under their farm names in place of family names. *Tir Barwn; Pendre; Tai Teg.*[6] There has always been a sense that you are connected to the land on which you live and farm; far more so than a surname that could belong to anyone else in the school.

5 Sampson, *The Scholar Gypsy*, p.88.
6 Translations: 'Baron's Land', 'Top of the Village' and 'Fair Houses'.

Knowing people in this way is a very particular method of placing someone within a landscape and forging connections not only between their literal geographies but also the relationship they have with the land. These were the children of farmers, they grew up on tractors and quadbikes, with sheepdogs and lambing seasons, and by association I was allowed as a child to see lambs born wrapped in silken sacs, to bottle feed those without mothers, to let calves lick my fingers with their rough black tongues and spend entire summers playing in hay-bale fortresses. As these memories flood back, I'm left with an intense appreciation for these tiny roads, winding rivers and rich, green fields.

I'm sure now, that their lives were not as romantic as I imagined them to be, but as an outsider it always seemed the most wonderful thing to be so intimately connected to the land in these ways; to depend entirely on the soil and weather and seasons. It had started to dawn on me as we drove home the night before that the realities of these livelihoods were probably always quite different to those I'd witnessed as a child.

Beyond these memories, I find that my mind strays into wonderings about the future of this place and my life here. The new builds, which seem to be consistently arriving at the edges of the village with each visit home, and the less-familiar faces I encounter on walks across

the fields feel like unsettling, yet inevitable, changes. My eye is drawn to the empty, tarpaulin-drenched scaffolding encampment towards the bus sheds; the breeze rippling through their plastic coverings. My mum informs me that they're being built by 'the buses', by which she means the village bus company, whose bankruptcy had slowed the building works, and so the houses sit abandoned, shrouded in their plastic shawls. This financial revelation comes as little of a surprise considering the infrequency of their bus services.

———— ◆ ————

Seasons can be marked here not only in the visual changes but also in the smells, sounds and rituals of each new month. Autumn's ripe blackberries, damp umber leaves and the peaty smell of full cowsheds on walks which lead you across farmyards in order to avoid the deep, muddy fields. Winter with its hard ground and thick frost: characterised in our school days by months of having to climb over the fence into the field across from the house in order to avoid the icy tarmac road which led down to the bus stop in the village. The dark, cold months are also a time of having to park the car miles away from the house in order to be able to get onto a gritted road to buy a pint of milk or fresh

vegetables. One winter, we spent the early mornings of three consecutive days clearing snow from the road up to our house and gritting it with the crystalline amber salt from the roadside in preparation for the oil tanker, which finally made it to us by the third day.

Each year, the seemingly endless cold depths of January give way to the tiny green buds of spring and the smell of defrosting earth. The quiet winter consistently replaced by the sounds of lambs bleating across the valley and the bright, joyous faces of daffodils at the roadside: heralding the warmer months to come. In time, the daffodils slowly curl back into the earth and in their place unfurls the summer, the season which stretched out before me now, its presence gently nudging at my senses in the early sunrise, the smell of mown grass and the bright gurgling of swallows as they flutter to and from their eave-tucked nests. Warm yet unpredictably damp; filled with river swims and tiny wild strawberries.

———————•◆•———————

From the top of the garden, overlooking the summer landscape, my mum begins teaching me how to dye with indigo. The fabric had been left to soak in water overnight and now sat damply in a wide enamel bowl, waiting to be plunged into the warm indigo liquid. Her

hands are gloved with old dye, a faded blue that clings to her fingernails in translucent crescents. She instructs me to take a piece of the cotton and submerge it in the vat. The moment the fabric breaks the blue-black surface of the liquid, I see that beneath is unexpectedly green as river algae. Steam rises around my elbows – the warmth of the indigo meeting the cold edge of the day. I hold the fabric under for two minutes, counting slowly and trying not to allow myself to be distracted by the insects which suddenly begin making appearances, drawn to this damp, shaded corner of the slowly warming garden. Hoverflies try to settle on my elbows and back, and I shudder instinctively to keep them off. Wasps, still placid enough at the dawn of summer, strike up an incessant hum as they weave in and out of the log stacks.

Once the two minutes are up, I pull the fabric steadily out of the vat and it re-emerges gleamingly wet and bright green. I hold it out to my mum, searching for her approval as I had done in childhood when presenting her with something I'd made. She instructs me to hold it in the air for a moment, allowing it to oxidise before hanging it on one of the bamboo sticks that she had stuck into the wall of logs at the other side of the woodshed, and between the pear tree and the willow. The fabric between my fingers turns from green to a cerulean blue. It is beautiful.

The slow yet sudden colour change as the indigo oxidises is completely mysterious to me. I can't imagine that I will ever lose a sense of wonder on seeing this entirely magical transformation.

It is surely this alchemy which lends itself to the symbolic associations that prize indigo as both protectively and spiritually important. The production of indigo dye is something of a chemical mystery: the transformation from green leaf to blue dye then to green vat and back again to blue cloth is a dizzying sorcery, which produces a colour that endures long after other colourants have faded. As Jenny Balfour-Paul noted in her book gathering a cross-continental history of indigo, 'the only colour of the Bayeux tapestry that remains true is the indigo blue of its woad dyed wools'.[7]

The morning continues in a repetitive yet infinitely exciting process of dipping and oxidising pieces of material, then re-dipping pieces after they have been oxidising for around ten minutes (or the length of time it takes for us to get back around to each piece of cloth). By lunchtime, we're surrounded by strips of blue fabric in varying shades; from a washed-out Aegean to a deep, turquoise-black. On some of the pieces the colour has

7 Jenny Balfour-Paul, *Indigo: Egyptian Mummies to Blue Jeans*, (London: British Museum Press, 2011), p.5.

clung to folds in the fabric, creating waves across the surface. My mum wasn't happy with these, observing them with a gentle cynicism. She was trying to create smooth, perfectly dyed cloth and these folds and uneven surfaces frustrated her. For me, the imperfect ones are equally magnificent as they sway peacefully in the summer breeze. They remind me of the sea.

Whilst we're working, my mum talks to me about travelling through Japan. Her stories shift between the most recent trip and the one she had made decades earlier. As a recent graduate, she'd left London with a plan to support a dream of visiting Japan by working on farms and teaching English. Whilst there, she found herself collecting pieces of *boro* textiles and simple blue-and-white *imari* ware from second-hand markets in and around Tokyo. She had also journeyed to visit the ceramic workshops of Mashiko, where the potter Hamada Shōji had established a studio on his return from St Ives, where he had worked alongside Bernard Leach to establish the Leach Pottery. Hamada was a founder of the Japanese *mingei* ('folk craft') movement, characterised by a methodology that prioritised simplicity and functionality alongside the use of local practices and materials. She recalls it as a place surrounded by lush green rice fields, where a girl she'd met in town had given her a lift to the station on the back of her

motorbike when she feared she'd miss her train back to Tokyo. She found the town to be too saturated with ceramics to recall any specificities of the potteries clearly from memory, but what she did hold on to from that first trip was the deep appreciation with which Japan valued the inheritance of its traditional crafts. Handmade, thoughtfully made, everyday objects are things to be cherished.

There aren't many photographs of her from that time, a consequence of lone travels, but those I have seen show her with cropped dark hair, wearing cotton *hippari* jackets and pull-on *mompei* trousers with worn-in Dr. Martens; pieces of clothing that now hang in my own wardrobe. Travelling with her Olympus OM-10, she took hundreds of photographs, though sadly not all were ever realised, as at some point during the trip the lens became loose and bleached the film. Between photographs of food markets, rice fields and the small backstreets of Tokyo where she lived, there are a collection of images documenting the indigo *noren*, which hang at the entrances of shops, cafés and restaurants. These indigo hangings reappear in the digital photographs from her most recent trip. As we stand between rows of dripping indigo fabric at the top of our garden in Wales, I think of this same colour as it exists in those photographs; in the doorways of ramen shops in Tokyo and the fabric

used to make workwear jackets and trousers. I notice how it is picked up in the landscape around us: the purple seat of Cadair Idris in the distance; the black of the river, which cuts through the village; the ripening blackcurrants bursting through the hedges in our garden. Suddenly, between lengths of blue fabric and the buzz of insects, Wales appears as a landscape of indigo.

———◆———

The morning's dew has long evaporated from the ground surrounding the woodshed, replaced by tiny blue droplets escaping from the continuously dripping fabric. The bare ground is blue in sprawling patches around the vat. There are makeshift bamboo drying rods balanced between the woodshed, and the willow and pear trees that grow beside it. The grass beneath them is now sprinkled with dye. It is well after midday and our stomachs ache for lunch. Although the morning has been punctuated by brief pauses for cups of tea between dips, we only really leave our vat-side posts once we've reached a natural lull in the process.

The long-anticipated break arrives between the dyeing and the rinsing. For lunch, I chop a bunch of parsley from the garden whilst mum cooks an onion in olive oil. Once the onion has softened and turned translucent,

she adds a splash of soy sauce and the salty dark liquid bubbles furiously against the hot aluminium of the pan. Next, she tips in a bowl of left-over brown rice from the fridge and allows it to cook for a moment until it's warmed through. It's late afternoon by this point and we drink peppermint tea and eat out in the garden. My mum uses a pair of chopsticks brought home from that first trip to Japan and I find myself asking her about their story. She tells me that a friend, whom she'd long lost touch with, had given them to her. Chopsticks are often sold in Japan in family packs, with two large pairs for parents and two smaller ones for children; having had no children of her own, the friend had passed on a smaller pair to my mother. As children, my sister and I had been handed chopsticks as readily as knives and forks, though for a long period I can remember using a single one to spear pieces of vegetable into my mouth rather than engaging in their proper use. It took years to be able to mimic the nimble fluidity with which she used them to clip pieces of rice and vegetables into her mouth via small saucers of sharp plum vinegar or soy sauce.

Talk naturally turns to the food she had eaten in Japan. Innumerable bowls of rice, and various forms of pickled roots and vegetables. She had been studying on an indigo farm in Fujino, a village in the foothills of Mount Fuji. Each night they would eat a meal of small plates, called

in Japan *ichiju-sansai,* meaning one soup and three dishes. The suppers would be composed of a kind of soup or clear broth alongside brown rice, vegetables, tofu, salads and pickles. One evening it was mochi cake toasted on a barbeque, so that it puffed up before being added to an umami broth; another it was a warmly spiced Brazilian stew. These were almost always eaten alongside rice but sometimes with noodles. One evening they learnt how to prepare noodles, stretching pliable lengths of dough before cutting them into strips and boiling. She shows me short videos on her phone of the noodle-making and of the flat yellow noodles being stirred through the bubbling water with wooden chopsticks.

The next image along in her phone is a photograph of the indigo farmhouse. Whether because of the quality of the photograph or the time of day – it must have been taken at dusk – the house and landscape beyond are compressed into swathes of blues and purples in that kind of electric discolouration phone photographs taken in low light tend to have. Late spring blossom hangs from the branches of a cherry tree at the door, appearing as a purple freckle of pixels along one corner of the image. Outside our own house, the plum tree is now drenched in a cloak of green leaves but it takes very little effort to imagine how it looked in the spring, covered with a gentle white blossom.

———— • ————

After lunch, we gather the slowly drying pieces of indigoed fabric into a bucket and set off down the hill towards the river. We climb a gate and cross two fields, carefully avoiding the cows. The dirt track created by quadbikes and trailers that runs through the fields has cracked and baked in the warmth of May and it's a relief to not have to wear wellies. In the winter the mud here easily becomes ankle-deep, sucking your boots into a terrifying vacuum, from which you may successfully pull boot and foot intact, or you may well simply pull out a bootless sock and have to hop whilst retrieving your lost welly from the sludge.

The river widens across the fields and on that first day of dyeing, it pushes its shallow weight slowly over the rocky bed. Taking off her shoes, Mum wades a short way out into it and climbs up onto a flat piece of rock raised from the riverbed, with trousers rolled up high over her knees. I watch as she takes a piece of the newly blued cloth from the bucket and submerges it into the running water. A dark blue river flows from the fabric, melting into the clear brown water and flowing downstream. She lifts it from the water, straightening her legs before returning to a crouch and re-submerging it.

I watch as she repeats this with each piece of cloth, her body an image of strength as she plunges and lifts the water-weighted fabric from the river. I'm reminded of the same strength with which she digs the garden each spring; sun-browned arms using a heavy spade to turn the soil of the vegetable beds her father built for us when we moved to this house in Wales fourteen years ago.

———•◆•———

It has been eighteen months since my grandfather's death, and yet I still feel overwhelmed when a T. Rex song comes on the radio, or when I pull one of his heavy woollen jumpers out of a drawer whilst looking for something to wear on cool evenings. At a work party the previous winter I had taken myself to the bathroom to wait out the uncontrollable tears provoked by Neil Diamond's 'I Am... I Said'. The song had concluded his funeral service, filling the damp, stone church and impossibly binding itself to the raw pain of his absence from that moment on. Somehow music is the most unavoidable of all reminders of his loss. Over the course of his life, I had unwittingly woven the melodies of his record collection into my memories of him, only becoming truly aware of how deeply I had done so once he was no longer there, listening too.

He was a gardener, not in profession but in life. Summer visits to his cottage in Lancashire taught me about planting seasons, vegetable growing and how to identify a multitude of different garden undesirables (i.e. weeds, of which there were many). Winter visits taught me the importance of a good book as I would take up residence in an armchair in the living room whilst he watched the same Westerns every weekend. Come June, I was designated the job of weeding the runner beans far more often than I would have liked. I remember feeling sheer panic after having accidentally pulled up a tiny bean plant after mistaking it for a fresh sprouting of white goosefoot. Although the tasks I was assigned were never the majestic ones of harvesting potatoes or pruning the orchard, I realise upon reflection that the menial task of pulling weed after weed out of the damp, brown earth was an opportunity to know my granddad, to understand something of his world; to take part in it. Since his death, gardening always reminds me of Sundays spent combing the bean rows for buttercups and dandelions, though now that his watchful eye is no longer marking my work, I tend to leave quite a few more than he would approve of. Watching my mum throwing piece after piece of wet, blue fabric against the glassy surface of the water, I am engulfed by a feeling similar to that of watching my granddad in his garden. It feels

as though, in witnessing this, I am being granted access to a very special way of knowing this person.

————◆————

Indigo is used in Japan as a protective material: it lines the uniforms of firefighters and was worn by samurai under their armour thousands of years ago. It is fire-resistant, anti-bacterial; it protects and heals. In searching for a way of making that could help her to process the loss of her father, my mum had inadvertently chosen to work in a tradition that had long been associated with mourning. Indigo can be found woven through the funerary wardrobe of Tutankhamun, the hand-dyed *ikats* worn by mourners in Central Asia and *uldebe* funerary cloths made by the Dogon in West Africa. My mother's pursuit of indigo had been inspired by a longing to learn more about this ancient material and the colours it produced rather than its significant connections to universal mourning practices. It was only through the conversations she'd had whilst travelling in Japan and through the books she'd sought out on her return that she began to fully understand the colour's true significance at this particular moment in her life.

Art seems so often to work in these subconscious ways; the mind and hands pulled by threads of inspiration

without too much planning or scrutiny. For my mother, there has never been a desire to examine why she's working in a particular way or with a particular material in the moment. These revelations take the form of reflections that occur later, through conversations taking place long after the work has begun or has already been completed. There is always a sense that she is following a thought through as it emerges rather than planning ahead: allowing herself to be completely present in the making process.

———————◆———————

There is a certain quality of mindfulness to be found in each of the processes involved: the steady counting of two minutes whilst each piece is in the vat, the rhythm of re-dipping each piece multiple times and then the repetitive motions of rinsing of each length of fabric individually. Each piece is dipped and re-dipped with care and the rinsing process is no different. My mum maintains unbroken focus, ignoring the severity of the water against her skin; though the quick reddening of her hands and wrists suggests it must be bitingly cold. A silent determination surrounds her as she works to replicate the methods learnt thousands of miles away. On reflection, the natural patterns of mindfulness

inherent in the dyeing process are just as deeply connected to the remedial quality of indigo in a time of mourning as the colour itself is.

Once rinsed, each piece is passed to me for wringing out and holding until the bucket in which we had carried them down to the river is empty and ready to be refilled. The results of our work are rather unpredictable: more washed-out than I'd imagined and some with wrinkled dark blue lines or thumb-print corners. They are beautiful in an imperfect way. There is a Japanese word for this kind of aesthetic: *wabi-sabi*. There's something to be said for a kind of beauty which encompasses the imperfect, the uneven or damaged. It's the same kind of appreciation that lends itself to the honouring of a well-worn pair of jeans, unique to the wearer and infinitely inimitable. The rippled indigo which my mum points out as being technically flawed, I find wonderfully beautiful. Within them you can see evidence of the slow acquiring of a skill and the imperfect results which unavoidably accompany that. The journey towards mastering a craft becomes visible in these uneven indigo patinas and in the patchwork of colours which now fill the bucket at my feet.

———•———

We take turns hauling the bucket filled with damp, freshly rinsed fabric across the fields, swapping as soon as our hands develop a red, handle-indented band across them.

It's past 7 p.m. and yet the sun shows no willingness to bow below the opposite hill. Our working day draws to a close, signalled not by the sunlight but rather by the aching of our bodies. We arrive home and peg the pieces of cloth onto the washing line at the bottom of the garden, where their wet surfaces shine against the sun. Standing back to admire the day's work, we note the number of dips required to achieve the varying depths of blue, choosing our favourites from the collection.

And so, the day concludes with a neat row of indigo flags obscuring the fields beyond our garden. The valley is filled with the bleating of sheep, as herds move to sheltered ground for the evening, and above the fluttering wall of blue cloth, buzzards make their final hooped laps through the apricot evening sky.

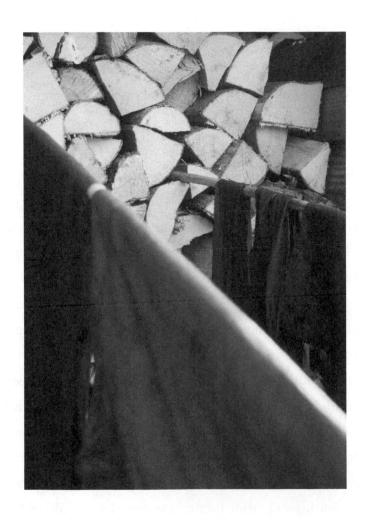

Chapter 3

A Landscape of Indigo

On Sundays, when my sister and I were children, our parents would often make the drive through Eryri towards the coast. Each weekend we would arrive at a different patch of coastline and be marched up and down the beach before being allowed hot chocolates or ice creams, depending on the season (or our moods). I would drift in and out of sleep in the car, a habit I seem unable to kick. I doubt I've ever remained conscious for the full length of a car journey longer than fifteen minutes. Yet, the stark changes in landscape along this route from our village to the coast mean that whenever I do resurface from sleep, I can tell exactly where we are along the route simply from looking out of the window.

Setting out from home, we would drive along the flattened belly of the valley and through the rich, green and watery Betws-y-Coed. Along the roadside, walkers gather in groups, propped up by walking sticks and with

packs high on their backs, like fleece-wearing beetles preparing for long hikes up to Swallow Falls. Allowing my eyelids to close for a moment, I next open them to see we're moving along the winding grey road that leads through the low foothills of Eryri: a craggy landscape peppered with sheep. It's not difficult to imagine steely-scaled dragons sheltering in the crooks of mountains here, their great hoards of treasure amassed in vast caverns below. There is a sense of being close to myth ology in this geography: as though you could slip through into another world at any moment. Towering and toppled cairns mark the peaks of hills and mountains, where one can walk for hours without encountering another soul. Pools of black water spill out across the valleys between the slopes and the boggy ground in between is covered in *Juncus* rushes and rough wild grasses.

The feeling of Wales as a landscape of indigo sticks with me. I cannot shake the urge to take note of each new shade that my eyes are hungrily drawn towards as we remake the drive over towards Ynys Môn one day in early June; quickly tapping them into my phone then locking it and returning my gaze upward to the window in a swift motion in order to reduce the prob-ability of travel sickness. As we pass the lakes which settle between the mountains, they remind me of the vat currently sitting dormant in our woodshed. Bottomless,

green-black reserves of spring's rain absorbing the flint sky above. The blue-grey rocks on their banks dressed in lichen. I watch the hills sulk past the window, cloaked in powdered blue and charcoal. Just beyond Eryri, we drive through the quarry town of Bethesda, past the terraced houses with their dusty, rain-worn, purple-slated roofs. The whole landscape seems drenched in the shades we'd pulled from the vat the day before and I realise that my familiarity with indigo in its many forms must have been long ingrained without my knowing.

Crossing the Menai Bridge over the fast-flowing waters of the Strait onto Ynys Môn, we stop at a small supermarket to source picnic food for the day ahead, returning to the car with a baguette, a wedge of crumbly white cheese and a punnet of the first strawberries tied into a small cloth bag slung onto the backseat. The geography of Ynys Môn always feels gentler than that of our home county, Gwynedd; the spaces between hills seem wider, making it feel as if there is slightly more sky there. We drive along roads that steadily decrease in width until we reach the single track that winds through a forest towards the beach. The track is punctuated by wooden placards, which inform us that the forest is home to a scurry of red squirrels. I look expectantly out of the window but am unsuccessful in catching sight of one; there are too many of their dusty grey counterparts.

It is a day before the schools break up for their summer holidays, and children have not yet descended onto the beach, scattering plastic buckets and abandoned sunhats in their wake. In fact, the beach is almost completely empty and, save for a sprinkling of dog walkers, we have the sands to ourselves. We follow the waterline up towards the end of the beach where, in low tide, it is easy to cross the damp sand onto the island of Llanddwyn, which sits at its farthest point. In actuality, the island only truly exists as an island in the highest of tides, yet it still feels somehow entirely separate from the beach as we pass through its weather-worn gate. On a still and scorching summer day, it can feel Sicilian; with black rocky outcrops bursting from the clear, turquoise water providing resting spots to swim out to from the sandy cove. In winter, hard waves and bitingly cold winds transform it into a tumultuous landscape, from which you can look uneasily outwards from the cliffs onto the black, foaming sea below. On particularly harsh winter walks, we tend to take shelter along the side of the boat shed on the slope down towards the cove for a moment of respite before heading back along the beach to the car, where a flask of hot tea is always waiting.

The island's name, like that of our village, is derived from the history of its chapel. Llanddwyn, meaning 'the

church of Dwynwen', refers to Santes Dwynwen, the Welsh patron saint of lovers who, it is said, lived her life as a hermit on the island during the fifth century. The site only became established as a point of pilgrimage (particularly for lovers or those seeking romantic assurance) during the sixteenth century and at that time, a new chapel was built on the ruins of an old prayer house thought to have been the one used by Dwynwen herself. However, both chapels have now long fallen into ruins and are marked only by their crumbled foundations. A shell-paved path winds along past the ruins, towards a white-washed lighthouse atop a hill at the far side of the island. Yellow bird's-foot trefoil and purple flowering thrift pattern the verges along the white trackway. Nestled in between the lighthouse and the old remnants of the chapels are a row of four low white cottages with blue doors and slate roofs. We pass them, shells crunching beneath our shoes, as we make our way down a duned slope to the swimming cove tucked to one side of the island.

Leaving the shell path, I slip my shoes off and feel the cool sensation of the white sand against the soles of my feet. We have been swimming at this tiny beach cove for years, spending summers and warm early autumn days doing laps of breaststroke around the bay. Sometimes, when it feels a bit too cold to swim, we sit

on the edge of a dune to make a few watercolour drawings of the island and the sea beyond – gathering sea water in oyster shells for rinsing our brushes between colour changes.

Today, the sun is warm. A few people are already in the water, their heads bobbing above the silky, translucent tide. We quickly change into our swimming costumes; the sea breeze hitting our bare skin. Everything must be done swiftly in order to minimise the time for mental retreat: is it really warm enough? The answer is given as soon as our toes plunge into the clear, cold water but there can be no going back. Ankles, knees, thighs, stomach, shoulders. In, in, in! All of a sudden, we are swimming and the adrenaline dutifully begins to keep us warm. From here, you can look out across the water at the blue peaks which line the opposite shore of the Llŷn Peninsula, a strange yet harmonic origami arrangement of folded earth glowing in the haze of the afternoon sun. My mind wanders back to the photograph on my mum's phone of the farmhouse nestled between the blue evening hills. Then, I am brought back to the present, noticing my fingertips as they push through the water, propelling me forwards towards the lighthouse, still stained with the indigo of the day before.

———— ◆ ————

The ocean in a bucket, the metallic blue rose of the vat reminiscent of a storm-weathered sea's surface curdled with foam. The next day, it sits patiently waiting for our hands to break the surface, like that first stroke into seawater. My mum gently stirs it to check the colour, telling me that beneath the copper-like surface it must remain green, and as soon as it turns blue it's no good.

In these early days of summer, we can only dip over the course of the morning, before the liquid beneath becomes a silken, oxidised cobalt. The cloth we rinse at the end of the day is a soft cornflower blue, with deeper shades coursing like tiny rivers down the fabric. But as the weeks pass, I observe as the recipe is slightly adjusted. My mum exchanges emails with her teacher in Japan; his replies come slowly and in the middle of the night, offering both advice and small updates on life in Japan as the temperatures rise and the summer rains set in. She spends days dyeing and evenings reconfiguring the vat recipe until the results are finally more stable, more even. A few weeks pass in this way, with our eyes glazed by the glare of Google pages and email screens, and noses buried in books borrowed from the library, until finally the results more closely resemble those she'd encountered outside the cherry-blossom farmhouse in Fujino and the vat becomes stronger.

By July, we arrive at the woodshed each morning to find the verdant liquid waiting for us to resume our work.

I watch as the shades of the dyed fabric become steadily darker, more even, and my mum's spirits rise in correlation. Standing amongst lengths of indigo-dyed fabric suddenly feels transcendental and the work creates a deep sense of calm between us. Any tensions of moving home somehow dissolve. I forget about not being able to drive and no longer miss my routine of walking to work in Scotland, where I bake cakes above a café in a tiny kitchen whilst friends drift in and out with tales of their days. It reminds me of one summer in Spain, standing on the rooftop of a Sevillian house as the white laundry dried in the evening sun around me. There is something gently comforting yet ethereal about being surrounded by swaying fabric, its evaporating dampness being lifted into the rays of sunlight which slice through the pear tree.

———— ◆ ————

Towards the end of June, my mum produces a heavy bag of brown rice flour from one of the boxes in her studio, announcing that we will be using it to make nori rice paste for resist-dyeing. I have seen samples of this work

in books we'd borrowed from the library and knew that intricately cut stencils pushed through with the paste would produce undyed lines on the dyed cloth. I have seen a length of cotton my mum had resist-dyed in this way whilst in Japan, covered in abstract poppy seed heads repeated in pale lines along the length of blue fabric. Yet the process itself has remained a mystery.

That evening, I watch as she shapes palm-sized balls of a glutenous rice-and-water mixture before placing them into a bamboo steamer above a pan of simmering water on the stove, their damp smell filling the kitchen. Once steamed, their plumped forms are transferred to a mortar and squashed one by one from little white dumplings into a thick gluey paste. A little cloudy lime water is added whilst pestling to increase elasticity, along with salt water to help the paste retain its moisture so that it can be used the following day. My mum is responsible for this and I am tasked with pushing the resulting paste through a fine sieve with a small, wooden spatula. The process is monotonous, and the radio keeps us company as we fall silent in concentration.

The work was begun in the gentle light of dusk and finishes under warm yellow lamplight. It is already 11 p.m. by the time the box beneath the sieve is filled with the jellied yellow paste. Our arms and wrists feel strained, and our tempers cut a little shorter than when

we'd begun but eventually, we are left with a Tupperware box filled with paste. Its thickness is comparable to a wet cake batter, only far stickier than any cake mixture I've ever encountered. Mum presses a lid over the Tupperware and safely stows it away in the fridge for the night.

By the time I go downstairs the following morning, she has already covered our kitchen table in roughly cut pieces of cream boiled wool. They are small portions cut from a woollen blanket that are to be the canvas for her *katazome* stencils. The stencils themselves are dark amber in colour: cut from a mulberry paper called *shibugami* which is waterproofed by being soaked in persimmon tannin. After a stencil has been cut from the paper, a fine layer of silk mesh is applied to one side with a strong lacquer to reinforce it for repeated use and washes. She has used the two stencils she'd made in Japan and they lay in a tray of water next to the pieces of clean wool. One shows an elongated poppy seed head rendered in undulating, curved lines; the other, two crosses composed of repeated, intersecting lines. I watch as my mum spends the next hour pushing rice paste through the stencils onto the wool using a small cedar spatula, then waits for them to dry.

Over the course of the morning, we take it in turns to occasionally blast them with the hairdryer to speed up the process. However, we are generally content to be

patient, sipping cups of delicate green tea grown on the fields around the indigo farmhouse as we wait.

Slowly, the paste darkens and pulls the fabric in tightly where it has been applied. My mum tests each piece's readiness by pushing lightly against the pasted lines with her fingertip: judging whether they are dry enough to be plunged into the vat. Once they are all considered to be ready, we take them out to the garden to dip.

Lifting the lid of the vat, we are met by the distinctive, now familiar smell of the indigo. It is a kind of damp, green, fermenting, metallic smell which hovers above the air in a non-intrusive but unmistakably present sort of way. We commence the routine of submerging, counting, oxidising and re-dipping. However, after the second dip we notice that the paste is peeling off in the vat, leaving the lines of the stencils broken and indistinct. The pieces cannot withstand a third dip and the effect is painfully depleting; the hours of work making the paste the night before feel wasted. The results of our labour are nebulous lines of periwinkle wool against pale shades of indigo. The paste has abandoned the material completely in parts and in others has allowed the dye to seep softly beneath its edges; just enough to create indistinct patterns across the coarse surface.

Two weeks pass in this way; Mum making and remaking the rice paste to slightly altered recipes just

as she had with the indigo vat. Translating the processes and techniques she had been shown in Japan to our garden in Wales is not a simple task. The water is different, the temperatures lower, and the materials available vary. Her early attempts at replicating the rice paste work she had made in Japan were both frustrating and time-consuming. Reaching for the clear white lines against deep indigo that she had brought home with her seems impossibly difficult and we spend hours making paste that can only be tested by dipping the stencilled pieces into the indigo vat. Yet, there is a sense of unrelenting determination in the way she works.

The change happens overnight. We prepare the paste in the evening and the next day it clings to the fabric after the second and third dips. We spend the warm July afternoon warily dipping the woollen fragments, watching anxiously for any signs of the paste disintegrating into the liquid of the vat. However, the pale lines remain firmly attached; shining wetly against the rough wool. Once each piece had been dipped sufficiently and oxidised for the final time, we fill a wide black bucket with water and begin to rinse off the paste by rubbing the wool between our fingers. The orange dusk sky ripples in the surface of the water as we rinse each piece before hanging them along the washing line between the plum and ash trees at the bottom of the garden.

The swallows dart wildly through the sky as we work, enjoying their evening meal. By the end of that day, a line of indigo flags patterned with organic white shapes hang steadily against the still twilight. The flaxen lines of the rice paste, which had been faintly visible against the cream wool, now shine brightly against the deep blue.

———— ◆ ————

We reach midsummer and the forest above our house blushes pink with foxgloves. The indigo hanging on the line at the bottom of the garden is reflected in shiny, ripe blackcurrants bursting from the bushes next to the plum tree, which holds the small, green baubles of unripe fruits along its branches. The lawn is spread with daisies and clover, smelling sweetly as we stretch out on the grass for our mid-morning coffee break. A pattern of dyeing has been firmly established by this point: the recipes configured and it seems as if finally, the real work can begin.

Each day starts with setting up or reinvigorating the vat and ends with our hands feeling fiercely cold from rinsing pieces in large horse feed buckets at the bottom of the garden (we are too tired to make evening trips down to the river by this point). We walk a short early-morning circuit through the woods and along

the fields each day and drink our mid-morning coffee outside in the honeyed warmth of a summer heatwave. The cows in the field opposite seek midday shade under the crab apple trees as we work with sleeves rolled up past our elbows and indigo bandanas tied around our heads to protect our scalps from sunburn. The hum of bees as they move between the raspberry bushes alongside the woodshed becomes the soundtrack to our working day.

The pieces of cloth hanging at the end of the garden have grown steadily bolder, now carrying not only the stencilled seed heads but also hand-painted images upon them. My mum began applying the rice paste directly onto the fabric; a technique called *tsutsugaki* in Japan. Drawings flowed freely from the pages of her sketchbooks onto wide pieces of wool and linen, conveying an abstract botanical landscape of twisting poppy seed heads, rosehips and teasels. Their shapes echo the collections of dried flowers and seed heads that fill old jam jars and milk bottles on the desk in her studio.

There is a beautiful freedom to the way she works – standing over the kitchen table, her mind completely focused on the task at hand – dipping long hog-hair brushes into the paste and drawing it stickily across the rough wool in short strokes so as not to spread the paste too thinly. A mosaic of drying pieces patterned the kitchen floor beside her, their lines slowly puckering as

they darken to a gentle yellow. Once these have been dyed, rinsed and allowed to dry, she lays the collection of indigo panels out on the floor of our living room against a white linen sheet, slowly arranging them into a quilt of drawings on wool.

Once her mind settles on an arrangement, she begins stitching the pieces together by hand, often reconsidering the groupings halfway through and unpicking the work already done. The process, the search for the perfectly balanced composition, is painstaking, with seemingly unlimited variations of arrangements. The visibility of the stitching becomes a subtle record of the time taken to make each piece. Each stitch a rosary bead, focusing her mind on the task at hand.

I think of how the multi-layered processes of making are so easily lost behind a completed piece of work. In witnessing this pattern of arranging and rearranging, I'm reminded of the X-ray images of paintings which reveal the multiplicity of compositions still in existence beneath the veneer; the hidden workings and reworkings of artists in their making processes. In many artworks we can find what are called *pentimento*, earlier layers of the work that the artist has changed or painted over entirely. Sometimes they can only be seen using X-rays or infrared imagery; others are revealed naturally by the progressive translucency of paint over

time. For a moment, my mind wanders to Picasso's blue paintings with their ghostly figures and floating objects hidden beneath the cool facade of the image and I'm reminded, too, that blue seems to return time and time again to artists as a colour of mourning.

My mum stitches to repair the loss of her father. As she does so, the indigo rubs against her fingertips and smudges her wrists. Briefly, as when she hauled soaking cloth from the river, I glimpse her former strength. Watching her piece together blankets of midnight blue, I witness the slow return of the focused way in which she had worked before grief veiled her vision.

———— ◆ ————

Wherever we go that summer, we find ourselves rummaging through junk shops, charity shops, second-hand stalls and car boot sales looking for old woollen blankets to dye over. Sometimes, we find ourselves driving over to the coast near to Aberystwyth, through the heather-strewn hinterland around Ceredigion, stopping along the way to scour narrow antique shops in coastal villages or in rusting tin outbuildings that smell of moth repellent and rainwater. Sometimes we arrive home empty-handed, feeling filthy from hunting through heaps of old fabric. Others we return elated, the

car boot bursting with bundles of cream-coloured wool.

The resist-dyed panels that my mum had spent the summer's early months painting and dyeing become vast indigo blankets showing a rich composition of line drawings. The botanical landscapes of the work merge the Welsh fields and forests around us with fantastical abstracted plants reminiscent of those found in medieval manuscripts and Persian miniatures. Towering foxgloves with drooping blooms hanging from long stems curled around short, curving oak leaves. The otherworldly, blue-and-white botanical collections of these works are inherently personal, their subject matter drawn from plants and pressed flowers she has collected over the course of years along local walks, the coast at Llanddwyn, her father's garden and our own. The landscapes they construct convey both a deep affinity with the natural world and her tendency to observe the beauty of everyday things.

Chapter 4

On Food and Foraging

Bewitched by the jade liquid of the vat, I have lost track of days and happily allow each to run into the next. The only suggestion of time passing is that I am no longer missing my daily walk for coffee and have grown entirely content with our stovetop offering. I also drink more tea than I ever have, though that is unsurprising as my mum has always been like this; I think there is rarely a moment when she doesn't have a half-drunk cup in hand and by then the kettle is already on for the next.

Making the tea for our breaks between dips has become my responsibility. Earl Grey, Keemun, hibiscus, masala and the campfire taste of lapsang souchong all have their parts to play in our daily routines. I prepare a pot and, once sufficiently brewed, pour the dark amber liquor into two enamel cups to take out to the garden. The ledge of a rocky wall that borders one side of the garden becomes our table as we work.

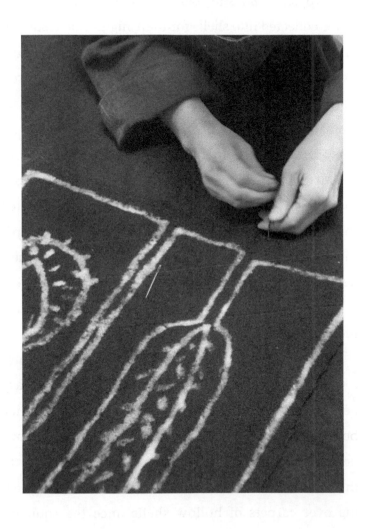

As children, my sister and I imagined the wall's craggy topography into a site for fairy feasts, leaving crab apples, wild strawberries, dandelions and pond water collected into shells for their night-time festivities in between lichen-covered stones. The landscape around us always seemed to be filled with edible treasures, waiting for our greedy hands to collect as many as we could before the birds or squirrels reached them. I have freed hungry blackbirds from the fruit nets around our redcurrant and raspberry bushes on so many occasions that I feel we're old acquaintances by now. As I watch them dart out from under the green mesh back towards the plum tree, I feel equal parts admiration for their determination to eat the juicy fruits and annoyance at the fact that they could easily clear an entire bush in a morning before we've sampled a single berry.

The countryside surrounding our house becomes a wild larder for the best part of each year. The heavy perfume of elderflower along the lanes turning to thick bunches of purple berries come autumn; wild strawberries hidden like rubies amongst the undergrowth throughout the summer; October's hazel thickets twisting over carpets of hollow shells once the squirrels have cleared their branches; and succulent blackberries in the late summer and early autumn, which must be picked before they turn to purple mush between your

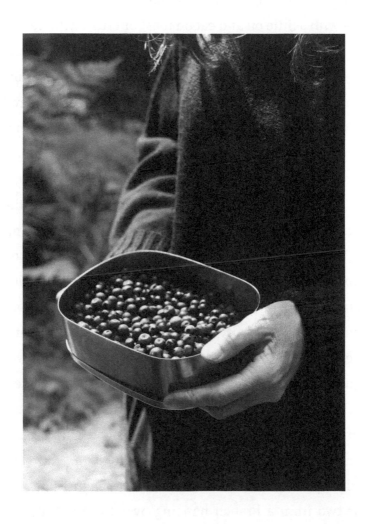

fingertips. Once the flat green leaves of wild garlic burst from the riverbanks in late March, we fill as many well-used freezer bags as we can and carry them home to fry with a little oil and eat on toast or crush with nettles and pine nuts into a pesto, using the delicate white flowers to garnish salads or pasta. In October, we take daily walks along fields where orange, green and red crab apples festoon the dark boughs of knotted, wind-pruned trees, their jolly appearance disguising their exceedingly sour taste. Sometimes, I cut a small branch of these shining baubles and place it in a jar at the centre of the kitchen table – a bouquet of late autumn.

The abundance of free, wild food in my childhood imparted a kind of specialised knowledge, one which only truly relates to the geography surrounding our home. I can identify these fruits, flowers, nuts and herbs elsewhere, but the level of understanding never quite translates to another landscape. Not immediately at least. Here, I know exactly when and where to find the treasures of the season. I also know the landowners; on whose land we can contentedly fill a cloth bag with apples and on whose we are best to just pull one or two from a branch hanging over the road. By the end of my four years at university in Scotland, I had developed a similar kind of relationship with the land-scape, memorising walking routes along tracks that led

past elderflower bushes or forest paths that sometimes offered chanterelles, but it had taken years to map out my surroundings in this way and the depth of understanding never quite equalled that of the walking boundaries of Betws Gwerful Goch.

———— ◆ ————

Just as the hedgerows can be used to orientate oneself within the year, the jars of jam steadily filling our kitchen cupboard likewise exist as their own kind of seasonal almanac. The first to arrive are almost always the deep red, seed-speckled confiture of summer's pink raspberries. Then, blackcurrants boiled into thick, black jellies shining through old honey jars. Come midsummer, a few rare vessels of deep-purple blueberry jam appear, quickly to be consumed generously spooned onto sourdough, porridge or late-night-snack crumpets. Plums and damsons fill the kitchen with their sweet, warm scent; spiced with star anise and bubbling into compotes before finally, the arrival of autumn heralds translucent amber crab apple jellies and the occasional batch of quince paste. The contents of the cupboard slowly diminish over the winter and spring – particularly at Christmas, when a few are always offloaded onto visitors – until the warm weather replenishes it once again.

———◆———

Each year, our summer garden becomes a jungle of tall herb bushes, entangled beanpoles and purple chive flowers sunning themselves from the dark earth. Most years, it is filled with an assortment of peas, beans, potatoes, carrots, beetroots and courgettes with the varieties changing annually. Some years, there are dark purple Capucijner peas hanging from a trellis of bamboo rods; others, the green curving pods of Lincoln's or flattened yellow mangetout joyfully sway in their place.

Gardening was passed down to my mum by her father. The summer we moved to this house in Wales, he built our back garden with slate steps cut into the hill and raised vegetable beds. For weeks we ate nothing but omelettes, and beans on toast, and chips made in the deep fat fryer he arrived with each time he came to do work on the house. Everyone was too exhausted from the work to do any other kind of cooking. Perhaps he's the reason a plate of salty, greasy chips remains my favourite food.

Since his death, it's impossible to sit amongst the vegetable beds without remembering the summer he spent working out here. My memory settles on him taking short breaks, always with a cigarette in one dirt-covered hand and tar-coloured tea in the other. Over the course

of his life, he taught us a kind of essential gardening. It was hard, sweaty, muscle-aching work. It was onions, potatoes, carrots and beans – an earthy lifeline. It was the kind of growing born of necessity, something he had inherited from his own father who had lived across two world wars in which, if you did not grow food, you struggled to eat. Because of this, our freezer has always been stocked with leftover summer crops well into the colder months, with sealable bags of frosted green broad beans and peas brought out to scatter into soups and stews over winter. My mum's garden is a little softer, she lets chamomile and poppies grow between the beds. But the purpose is the same: to feed a hungry family over the course of the year.

In the spring, the long garden table that my dad built when we first moved to the house would be strewn with seed packets and small crates holding chitted potatoes and onion sets sprouting tiny white roots. My sister and I would be allocated a small patch of a vegetable bed each to grow whatever we liked. One year, my patch of earth cradled a single, bright orange pumpkin tucked amongst the sprawling green vines. However, we would often be gently encouraged by our mother to grow radishes, as they prospered quickly and satisfied our childhood impatience. I didn't enjoy eating radishes for many years but the sight of their fat, rosy bodies

half-encased in the soil brought me such delight that I didn't mind not eating them. Occasionally, I would hazard a taste of a tiny one sprinkled with salt and stubbornly pretend to enjoy it but really, I found them peppery and unpleasant. Now, I can think of no tastier treat at a summer lunch table than crunchy slices of a freshly unearthed radish, washed, salted and eaten atop a piece of buttered bread.

———•———

Radishes were one of the few garden-grown vegetables my mum had managed to plant this year. In the evenings, at the end of a day of dyeing, we sit outside in the back garden and eat them sliced into salads alongside peas, beans and chopped herbs dressed in salt and olive oil. Once the first courgettes start to appear, they also join the mix and we eat them almost every night: finely sliced and grilled, grated into fritters or salads, chopped into a soup or a ratatouille. It was this way in my childhood, too, months of the elongated green vegetables cooked in every way imaginable until they finally drifted out of season. Once or twice, we had attempted courgette loaf cakes but they somehow always seemed a bit sodden and not the carrot cake alternative the recipe books promised us. Inevitably, a few outgrew the category

of 'courgette' and we were left with a couple of great, hulking marrows in the bottom drawer of the fridge that my mum had to quickly devise a recipe for. More often than not, they were roasted, their middles scraped out and mixed with brown rice, tomatoes and parsley before being returned to the green case, topped with feta and baked until crisp and golden.

Summer salads taste of fennel, mint, parsley and lemon balm, and puddings of fresh raspberries and red-currants from the fruit bushes next to the wood-shed. Perhaps because my mum had been away in Japan for a large part of the planting season, or perhaps because gardening reminded her too diligently of the absence of her teacher, there is very little to harvest from our own garden this year. Instead we find ourselves drawn to combing the wild for free, seasonal food to enliven our simple suppers and weekend baking.

———◆———

The weekend rituals we'd observed throughout my childhood remain largely unchanged, the most well observed being that there should always be something sweet around for the weekend. It is imperative that it be something easily transportable for taking over to the beach for a walk or visiting people. The recipes we follow

are often from the Cranks cookbook, a token of my mum's life as a twenty-something in London when she had worked at their café in Covent Garden. The book is well-used, its spine pulling away from the pages at both ends, secured only by a thin membrane at the centre. The most frequented pages bear inscriptions of sticky, cake batter splatters or the oily marks of a whisked salad dressing left by me or my sister. Mum was always far tidier when she cooked than we were, the books placed further from the site of preparation and their recipes already mostly committed to memory.

By the time I really took to baking in my teenage years, I quickly developed a tendency to rebel against recipes. It is a custom that still haunts me and I find myself rarely able to produce the same cake twice. My method tends to involve mixing together ingredients to form a good-looking batter, then baking until it looks done. Perhaps unsurprisingly, the results can vary from delicious to dreadful. My cakes are often like my mum's first attempts at indigo: unpredictable and flawed. But, irrespective of my many burnt, crumbly, salty or under-cooked misfortunes, baking has always been something that I associate with lifting my mood, particularly when creativity or motivation is in low supply. Like the imperfect blue cloth I'd admired dripping along the washing line, I realise that I enjoy the process of making

food so deeply that I'm often just as content with the unpredictable results as I would be with perfected ones.

Though I abandoned the methodological approach she'd passed on in childhood, baking was a gift given to me by my mother in a moment of deep, teenage angst. Trays of cinnamon buns, vegan peanut butter biscuits and honey cakes distracted my mind from the unavoidable fog of secondary school anxiety and have since seen me through every kind of heartbreak. If required, I can steady myself with a recipe, but I enjoy the spontaneous practicality of whisking butter or oil together with sugar, cracking in an egg or two followed by a cascade of flour and then whatever else I fancy.

———————◆———————

At the heart of our kitchen sits the heavy blue stove we've had my entire life. Everything is cooked on this Aga; an enamelled cast-iron cooker given to us by my grand-dad who had worked for the company years before. Designed by the Swedish physicist Gustaf Dalén in 1922, the Aga was developed on a principle of heat storage, and thus is always warm, always ready to cook on. Ours has two ovens (a roasting oven and a cooler simmering oven) and two equivalent hot plate rings. It throws a gentle heat out into the kitchen, magnetising

whoever is nearby to stand leaning against it with arms outstretched along the metal bar at the front where a tea towel or two are always hung to dry. In desperately cold times we sit on the rug in front of it, with our feet in the simmering oven to warm them up – a cold-weather habit learnt from our granddad. Our Welsh cottage, with its small, single-glazed windows, is half-built into the damp hill so, even in the peak of summer whilst the stove steadily pushes out a gentle heat, the kitchen rarely feels too hot.

The lifeblood of our daily existence – keeping us warm and fed and in many ways keeping us together – the Aga quietly became my granddad's legacy in our home. There is no better place to gather than around the dark blue stove; leaning against it or sitting at the kitchen table within the gentle reach of its cast-iron warmth.

———•———

Over the course of our childhoods, the old wooden kitchen table, nestled beside the stove, had become steadily engrained with paint; glitter shards; smooth, shining splatters of dried PVA and short pencil strikes where our drawings had run over the edge of the paper. Once we were at school, it became the place my mum would spend each day working and where we would

return home to sit, offering daily debriefs over hot cups of milky Earl Grey and crunching our way through a myriad of after-school snacks. These were usually (though not confined to): buttered toast spread with jam or Marmite, small round oatcakes holding slivers of yellow cheddar or slices of apple accompanied by spoonfuls of salty peanut butter, which glued itself to the roof of your mouth. In the summer, we'd be offered young, pink rhubarb stalks from Granddad's garden alongside a small saucer of sugar for dipping. These snacks were always simply constructed, timeless pairings. They're the kinds of things I still reach for when I get home after a long day, often finding myself slicing a rough, russet apple into segments and dipping it straight into the jar of peanut butter before having even shed my coat.

In light of this, it is perhaps unsurprising that when I look back on my university experience away in Scotland, the memories I hold most dear are those that took place around kitchen tables. I realise inadvertently that my life has taken place across a constellation of kitchens. My first term away was desperately lonely, save for the unintentional day-brightening conversations sparked between strangers in the shared kitchen of our halls of residence each time I ventured out of my room to make cups of tea. The subsequent second and third years were warmed by fresh loaves of bread, roasting trays

spread with vegetables, deep pans of curries and beany stews prepared in steamy kitchens. Finally, a final year of impromptu dinner parties, potlucks and slowly cooking ramen broth set at a rolling boil in a collection of pans across all four rings of the hob; filling the entire flat with a savoury, salty mist laced with sesame.

It was perhaps inevitable therefore that my under-graduate essays would be written across a series of kitchen tables, fuelled by an accompaniment of various traybakes and endless cups of tea. There is something infinitely beautiful about passing a friend in the street, both mid-way in our approach to difficult deadlines, and feeling them press their keys into my hands on their way to class, telling me to work from their kitchen table for a change of scene. Though I was unaware at the time of quite how essential food and cooking were to the enjoyment of my university years, writing an essay always seemed easier with a mug of Earl Grey and a slice of rosemary and olive oil cake sat beside me.

———— ◆ ————

A whisper of the arrival of *llus* spread along the forest floor towards the middle of July. The green ochre mossy woodland of Bod Petryal, a short drive away from our house, was suddenly sprinkled with dark blue

berries hanging from bright green stems. These wild blueberries, which arrive each year are – for me – by far the most exciting of all the foods in our unwritten foraging calendar. The window for picking is small: one day they are a dusty green, the next a deep purple and, if you don't get them before the birds do, you miss them entirely. The forest is filled with darting blackbirds and thrushes enjoying the feast, their bright chirruping carried through the trees as they move from one bush to the next.

We are bent double, picking for hours; filling boxes, bowls and bottles with tiny blue fruits. I tend to pick on a one-for-me-one-for-the-Tupperware basis, and my tongue quickly turns purple. At midday, we break for a flask of coffee and unwrap the brown paper from two spelt scones that had slowly defrosted over the morning in my pocket. The freezer at home always holds a small offering of scones: apple and walnut, date and cocoa nib, pear and sultana, and occasionally a herb and cheese. Loath to ever discard gone-off milk, whenever we find ourselves with a sour pint, it is swiftly baked into a batch of scones, which are then frozen for emergency supplies on days out, long walks or the arrival of unexpected guests. The flavour combinations vary depending on what else needs using, or what we have in the cupboard.

We return home, our fingertips stained a deep

magenta, and divide the bounty up into what we will use now and what we will freeze for later in the year. The jam pan is already sat stoically upon the kitchen counter. Weighing out half of the berries, we add equal parts sugar to fruit and set the pan on the stove to boil. The golden sugar slowly melts and transforms into a bubbling purple liquid. After a while, we test the jam on a cold plate; taking turns to draw a finger through it to see when it sets. I hover impatiently by the stove, waiting for the thick simmering liquor to be ready and decanted into jars, after which my mum offers me a piece of bread to swipe around the deep pan. I then spend the next five to ten minutes devotedly cleaning the pot; collecting as much of the fresh, warm jam as I possibly can.

The remaining *llus*, not destined to become jam, are poured into a variety of bags and empty yoghurt tubs to be frozen. Throughout the year, handfuls of the summer's frozen cache are stirred into porridge, warmed into compotes and baked into cakes, puddings and scones. Over the winter, a handful sprinkled into a pancake batter and baked in a deep tray in the oven until set and golden brings back memories of warm summer days spent in the shade of the forest, filling containers with wild blueberries.

———— ✦ ————

I visited an island in the Stockholm archipelago once and found myself becoming lost along the small mound of its existence, wandering without direction through an autumn woodland. As I walked, I looked down and saw the floor carpeted with the same low, brightly leafed bushes. *Llus!* I was overwhelmed with a sense of homesickness but also comforted by the familiarity of the earth beneath my feet. Knowing a plant, a flower, a forageable food grants a tiny connection to the earth – a magical sense that you're not lost, even if technically you may be. Years later, a field of poppies in Fife, bordered by blackberry brambles covered in a green bubbling of fruit had the same effect – somehow bringing my autumn purpose when I needed it amid the waves of loneliness inherent in my first few terms at university. I traced the periphery of their prickly tangle each day, watching their colour darken to a richly shining purple before filling a Tupperware and carrying them back to my student flat to make a large, solitary jar of jam that I lived off through the winter, spooned onto porridge or toast.

Like making art, foraging offers a kind of fulfilment in the simplicity of engaging with the world around me. It's a very different feeling to that of completing a project

through a phone or laptop screen, a Word document or PDF. It feels more straightforward, simpler somehow. And always far less anxiety-provoking.

My mother instilled a kind of all-encompassing creativity into even the most mundane of tasks. Preparing a meal, taking a daily walk, collecting boxes full of blueberries or digging over the garden each spring were acts just as creative, and valuable, as creating a piece of art. I noticed as I found myself joyfully seeking out blueberries in Stockholm or blackberries in Scotland, that it was a perspective I had inherited from her. There is something reassuring about being able to continue to observe the patterns and traditions she'd passed on, even whilst we were apart. In much the same way, there is a comfort in cooking on the Aga given to us by Granddad and planting seeds in the beds he built for us. It feels as though in that way, our relationship is allowed to continue.

———◆———

Our eating patterns follow the routine of the indigo vat. Just as lunch is only eaten once each piece of cloth has been dipped the allotted number of times and assembled to hang in the summer air for a while before being rinsed, supper comes at the end of the day's work.

If it becomes particularly late, I go inside and start cooking whilst mum continues her work. However, on shorter days, or damp ones when it is impossible to work outside, we cook together.

I've always been drawn to simple cooking. There is something immediately satisfying about devising the best way to cook whatever vegetables you have in the fridge – the fewer pans involved, the better. When we travelled to Italy on our paint-buying pilgrimage, we essentially lived on quickly fried cavolo nero and winter tomatoes on either pasta or bread for the week. After days spent gazing at brightly restored frescoes and densely hung palazzo walls, we would return each evening to the high-ceilinged apartment we'd rented behind the cathedral, craving quick comfort food with what few ingredients we could pick up at the market.

We grew up eating in this way: good, uncomplicated food. Like my granddad's gardening style, it's practical. It was food that filled you and didn't take all day to cook. I would be lying if I said a week passed where we didn't eat baked potatoes, as there really is no easier supper than a potato prodded with a fork and rolled into the roasting oven of the Aga. Left alone for half an hour to an hour, depending on how hefty the potatoes are, they can be ignored entirely until it is time to fill them with garden salads, baked beans or a freezer-cradled dhal.

———◆———

Halfway through July, we sip mugs of tea in the slowly warming sun and watch the steam rising from the indigo vat. It is mid-morning and already the garden has been draped in dark, dripping sheets of blue cloth, creating tent-like structures between the fruit trees. We weave between them, dipping, hanging, collecting and re-dipping in a quiet cycle. We've started dyeing tablecloths: vast lengths of linen inherited from grandparents, distant aunties and friends or found in junk shops and laundry cupboards. Some have small pieces of embroidery at their edges, delicate floral embellishments in the corners. Others are flecked by tiny moth holes. The nicest ones we'll use on our own kitchen table but those that are moth-nibbled or too kitsch with their elaborately embroidered edges will be repurposed. Once rinsed and dried, the dark sheets of linen are folded and stored in the attic studio to be cut into smaller pieces for working with.

A fresh path of blue speckles paves the ground between the vat and the bamboo sticks where we have been hanging the pieces to oxidise. She tells me that her teacher in Japan would have laid rush mats out along the route to prevent the ground from being stained by

the inky drips, but we both like the slowly fading galaxy of our repeated trips. The marks keep a record of our journeys along the length of the garden as we carry the dripping linen. By the winter they'll have faded and, come spring, the ground will have entirely forgotten our summer rituals.

———◆———

On drizzly mornings, we drive along the winding, single-track roads to town to spend a quiet hour poring over recipe books in the library, checking out a few for the afternoon or the days ahead, before shopping for their ingredients. The time we dedicate to cooking each day is largely dictated by whether we are out in the garden dyeing. So, depending on the weather, our evening meals could be a quick affair: producing large serving plates of linguine twisted through with lemon and courgette, generously peppered and grated with hard cheese in less than fifteen minutes. Or, something slower: thick stews steaming up the rain-speckled windows as they gently bubble away for hours or spheres of spelt pizza dough rising in tea-towel-covered bowls at the back of the stove.

We spend damp afternoons baking from our newly discovered library-borrowed favourites: Diana Henry,

Anna Jones, Rachel Roddy and *The Green Kitchen*. Then, wait out the summer downpours with their dark leaden clouds at the kitchen table, drawing or reading with a slice of cake and a large pot of coffee.

We return to recipes time and time again, revising them with our own tastes and creativity. A particular staple of rainy summer afternoons becomes the making of a sweet, enriched dough rolled out and filled with the remaining *llus* that haven't been cooked into jam. We cut the soft, filled dough into swirls and sprinkle them with chopped pistachios or walnuts before baking. It reminds me of a café I visited in Stockholm with a low, slate-grey bench out front where I had sat eating a blackcurrant and pistachio bun on a cool, May afternoon. It is the kind of recipe we'll go back to throughout the year, adapting it to whatever is in season. I think ahead to swapping the summer's *llus* for grated apples come September, then pears and blackberries later in the year. In this way everything we make somehow tastes of the landscape around us.

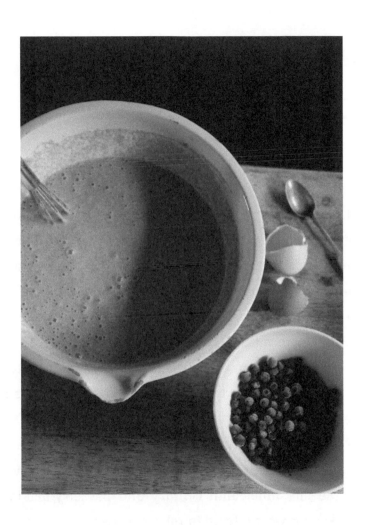

Chapter 5

Glas/Blue/Ao

It's nothing new, to focus one's mind on a creative task in order to recover from a trauma or to subdue the agitated chatter of anxiety. The thick layer of hand-knitted scarves which obscured the back of our front door in my secondary school years could easily attest to this – each one a physical testament to a momentary escape from misfortune or worry in my adolescence. Creativity, whether it takes the form of a midnight batch of cookies or a slowly growing piece of knitwear, is a healing force.

Craft courses have been prescribed to patients since the very beginnings of occupational therapy practice in the late nineteenth century and basketry-making workshops were offered to relieve anxiety and physical ailments amongst soldiers during the First World War. The meditative quality of repetitive, creative acts such as weaving, knitting or dyeing requires a certain level

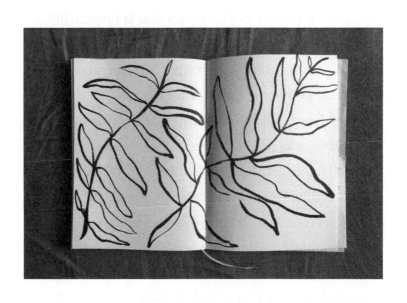

of focus, which in turn distracts from other stresses and keeps the mind anchored in the present moment. In psychology this is referred to as 'flow', a state in which the complete absorption in what you are doing results in the transformation of a sense of time. In paying close attention to the task at hand, we activate parts of the brain's cortex involved in regulating emotions and reduce activity in the region that is responsible for processing negative emotions and fear. In this way, making becomes an alternative kind of medicine, a remedial act to cure almost any ill.

The linen tablecloths we'd been dyeing are laid out across the old kitchen table, collecting crumb constellations in between washes. We swap them occasionally for a charcoal grey one made by my sister with hand-stitched drawings of hands along its edges. She brought it home last December, the first Christmas since my granddad's death. We didn't have a tree and I can't remember whether it was because we simply lost track of time and forgot, or whether the decision was made consciously as we couldn't face the rigmarole of the whole enterprise. Instead, we tied a long winter's branch along the window of the living room and hung it with small glass baubles. I wonder now whether her laboriously stitched offering for our kitchen table had been the product of a need to make something in the

wintry evenings of bereavement, a Christmas gift born out of a need to complete some creative task by means of distraction.

———◆———

I have now completely forgotten the exact date of his death, a fact which presents itself as a positive revelation rather than a lack of care. It must have been late autumn, as the funeral was a dark, grey affair with sheets of rain and sleet firing off the car windscreen and whipping our coats, scarves and hair around in a graveside tor nado. But my memory of the day itself doesn't extend very far beyond this. In its place, I easily recall the way he took his tea, the seemingly countless nicknames he invented for each of us, and the smell of freshly dug earth and stale cigarette smoke that clung to everything he owned even years after he had stopped smoking. Try as I might, I am unable to forget the fateful day that I made three heavily sweetened, double espressos for him over the course of an afternoon – at his request – only to be crossly informed the following day that his lack of a good night's sleep as a consequence of the caffeine was entirely my doing.

It is a strange and awkward transition, to move from a period of remembering someone as having died to

remembering them as they had been in life. Immediately following his funeral, I found myself knitting a long woollen scarf to distract myself from the relentless awareness of the loss. I spent time cooking from lengthier recipes, settling on anything that required my devoted attention for at least an hour, preferably longer. However, although I seemed to be in a constant motion of preparing deep pots of comfort food, preserving whatever I could find as I filled jars with pickles, pastes and jams, I noticed that my face and body seemed thinned out by the loss. The steaming bowls of rice pudding or tomato stews with glassy pools of olive oil on top didn't seem to have the same effect they once had when my mum had prepared them as remedies for difficult schooldays. It's difficult to imagine now, how I'd understood grief before receiving the news of my granddad's death from my mother over the phone in that time after the autumn break and before Christmas. I sat at the desk in my university room, completely alone and completely heartbroken.

My saviour was saltwater. I swam frozen lengths in the sea for the last few weeks of term before the winter break, allowing the cold water to clear my mind for as long as I could bear to stay in. Sometimes I pulled on a thick, black neoprene wetsuit but mostly I ran straight into the water in my swimsuit to feel the icy precision

of the water against my body. When I returned to Wales at the end of term, I moved this ritual into a startlingly clear chlorinated pool where the repetitive movements of each stroke were mirrored by my mum, who swam alongside me. We went to a pool just over the border in Chester, an old Victorian baths with poolside changing rooms and a lantern roof. Afterwards we drank coffee and ate bowls of porridge in a café around the corner.

I did not go straight back to university after the winter break; I had lost sight of why I had been there in the first place and wondered if I'd made the right decision in attending university at all. I took a leave of absence and spent a year at home swimming and knitting and watching the hedgerows change as I tried to decide on the right path to follow. My parents, paternal grandparents and sister had all been to art school but on a rebellious whim, I had chosen instead to study Art History. I saw it as a kind of academic alternative to the art school education I secretly wanted. My decision had also been motivated by my granddad, whom I had always desperately wanted to impress. I received an offer (somewhat surprisingly given my school attendance record) from the oldest university in Scotland and so I went there in order to make him proud. Though of course as I grew older, I realised that he had been proud of me long before I'd accepted that place at university.

After his death, I found myself cradling a sense of loss at having not gone to art school and felt painfully immobilised when it came to making the decision of whether academia was where I belonged. However, there was something about witnessing the first snow-drops and crocuses wriggling from the frozen earth, the fluorescent appearance of daffodils amid spring's fresh greenery and the sudden abundance of bluebells across the shady woodland floor in the forest above our house that provided a sense of clarity. The steadiness of nature's rhythms became a comfort in my hour of need: regardless of where I was, or what I was doing, its cycles of growth and regrowth remained beautifully consistent.

This particular sense of clarity comes to characterise days in Wales each time I return. The slower pace of life allows space for reflections, thoughts or decisions, which seem difficult to make sense of elsewhere. You feel, in many ways, apart from the rest of the world here. There is little necessity to navigate rush hours or queues, or the sense of urgency I've always felt in cities. Instead, your life is free to settle around its own patterns and routines.

Over the months following his funeral, the days grew longer and in synchronicity my life steadily seemed to regain a kind of normality, comforted by the repetitive routine of these everyday actions and the progression

of the seasons. I found the weight of the loss was slowly assuaged and once again felt able to move about daily life without a constant shadow of sadness cast across its everyday tasks.

The consolation of my mum's grief was of course slower than my own. Though I had known him for my twenty years of life, for her it had been fifty. It seemed to me that it was only now, once she could focus on creating a new body of work with indigo, that she truly began to process the grief of losing her father. The pieces of wool painted with rice paste, hauled to and from the indigo vat until they were a deep, sodden black and the adjustment then re-adjustment of recipes and methods could be nothing but labours of love. The work was exhausting and frustrating. Yet the way in which she thoughtfully attended to each task or new challenge was beautiful – perhaps the most beautiful thing I have ever witnessed. I watched as she steadily regained a sense of joy in making – re-finding her focus. Though the pace of our mourning differed, the methods were the same: we looked to creativity and nature in times of need. We swam and walked and made work, we refocused to re-situate ourselves in the world that seemed completely changed without that vital person in it.

———◆———

Indigo journeyed to our garden from Japan, though its colour has quietly existed in the botanical landscape of Wales for millennia, hidden within the green, lanceolate leaves of woad. A rich blue pigment is disguised behind the fluorescent yellow flowering plant just as it is behind the verdant pinnate leaves of the *Indigofera* from which my mum's powdered dye originated. Though wild-growing woad in Britain is now scarce, it can still be found in scattered locations across the country and has grown wildly here since at least 1800. Its history as an imported plant and dyestuff on this island reaches even further back: its colour was extracted to illustrate the Lindisfarne Gospels around AD 700.

The blue dye derived from woad was long mythologised as the warpaint of ancient Celtic warriors; it undeniably runs through this landscape, though it has been long forgotten. The Celts allegedly painted the dye across their bodies for the same antibacterial qualities ascribed to indigo by samurai. Though the vision of a cornflower people, awaiting the invading Roman army at the cliffs of Dover, seems appealingly romantic, evidence supporting this historical use of the dye remains much disputed. Caesar is believed to have declared, 'All the Britons, without exception, stain themselves with woad, which produces a blueish tint; and this gives them a wild look in battle,' but this translation of his words has now

been discounted by the fact that he never made it far enough north to meet many of the people who inhabited these lands at that time. It has now been widely accepted that a mistranslation of his words led to the substitution of the word 'woad' for a Latin word which more practically translates to a type of blue-green coloured glass favoured by the Romans, suggesting that Britons were tattooed in a colour which resembled woad, but were probably not painted head-to-toe with the blue dye as John White's sixteenth-century watercolour depictions showing naked blue warriors emblazoned with fierce, animalistic imagery would have us believe.

Looking across to Eryri from our hillside garden, I'm reminded that the mirage of Cadair Idris's blue seat will always remain just beyond reach. The moment you are within touching distance, the slope will have already turned a grey, stone-speckled green. The colour blue possesses this illusive quality. It remains almost impossible to grasp in the natural world, though we witness its wonder daily in the water, hills and sky. Its ephemerality in the natural landscape perhaps also explains that the words trying to contain it within linguistics are also characterised by a kind of vastness. The Welsh word *glas* can be translated to mean 'blue'; but it can also refer to the colour of the sea, of grass, or of silver. Similarly, the Japanese *ao* is a colour word

which encompasses blue skies, lawns, forests and unripe tomatoes and so, for English speakers, the linguistically defined borders between colours seem difficult to navigate. There is no universal understanding of 'blue', it evades capture in both the natural world and our man-made nets of language.

It is perhaps understandable then that we've universally attributed an ethereal significance to this colour throughout history. It was the divine pigment chosen to cloak the Virgin in religious depictions since around AD 500 and coloured the tiles of the Ottoman mosques and palaces, reflecting cool light across their sacred interiors. Ancient Egyptians entombed their ancestors wrapped in cloth dyed with woad in order to protect them in the afterlife. Indigo's natural antibacterial qualities have meant that it has been both spiritually and medicinally important across the world. In Eastern medicine, indigo leaves are added to tea and sometimes applied directly to the skin for burns or insect bites. In 2020, a traditional indigo dye producer from Aomori Prefecture in northern Japan began the production of surgical masks which incorporate indigo extract into their layers for the dye's ability to fight influenza viruses.

I often find myself reaching for pieces of indigo, tokens of the summer, in moments of need. The hair ties, jumpers, shirts or scarves that we dyed together

become amulets which protect against the struggles of everyday life. There is something exceptionally powerful about this colour – that of the sky, sea and hills.

———— ◆ ————

Over the course of the summer, the deepest shades of blue saturate not only the backdrop of our evening meals and the earth at the top of our garden but our wardrobes and sketchbooks, too. I witness my mum's sketchbooks become a monochromatic landscape of abstracted flora delineated in indigo tempera and destined to be painted with rice paste onto the blankets we'd been collecting. Once dyed, these become a negative of the drawings; otherworldly cyanotypes: the blue lines of her sketchbooks suddenly rendered in white wool.

Alongside these, we dip our old clothes. It begins with the dyeing of sun-bleached or turmeric-splattered favourites that require stain coverage, but soon the joy of dyeing takes over and almost everything we own is treated to at least a few soakings in the deep, viridescent vat. Our hands are semi-permanently stained with a leaden blue and there is often a jumper to be found hanging between the rows of rice-paste-painted woollen fragments, sometimes a linen apron or shirt. She also dyes a few skeins of pale lambswool, in preparation for

the colder months when dyeing outside will no longer be possible and her mind will need something practical to distract it from the long and dark Welsh winters.

Word of the vat at the top of our garden in Wales eventually spreads to friends and acquaintances. To fund the cost of purchasing the indigo, we begin accepting the occasional parcel of clothing to be dipped. On some pieces, the stitching remains undyed, chalk white against the inky blue. Indigo only adheres to natural fibres but most stitching in modern garments contains nylon and so it resists the dye, leaving contrasted stitches that run along the seams and tell of the previous lives of each garment and the joy to be found in renewing an old wardrobe with blue.

———•———

The days pass as if we are swimming through one of Chagall's all-consuming ultramarine skies. Our newly established dyeing routines provide a welcome stability to the warm summer holiday weeks we would have usually spent gardening with my granddad, distracting us slightly from the absence of these summer rituals.

The rhythms of dyeing softly interrupt the pain of loss and begin slowly mending what they can. One day in July, just over eighteen months since his death, my

mum begins to play her father's old records again. We are weaving in and out of the house, between woodshed and kitchen, going about our daily tasks as the heavy percussion of Fleetwood Mac's *Tusk* peals through the open windows and out into the garden. We begin playing our way through his vinyl collection, pulling dusty record sleeves from big plastic storage containers in the living room and allowing the sounds of T. Rex, Neil Diamond and Simon & Garfunkel to fill the house once more.

———◆———

Music was an integral part of my childhood, as I think it is for any child brought up in Wales. The school calendar was organised around choir recitals and, until you reached secondary school, being a part of the choir was not an optional extra-curricular activity. It was possible to pinpoint the time of year by listening to the melodies carried through the single-glazed windows of the classroom, inside which we would be arranged in a semi-circle and tirelessly conducted by a very severe music teacher who would come to our school each Wednesday afternoon. The familiar tunes that accompanied each seasonal concert would be played on the small, upright piano which we'd all fight over, stealing turns at playing 'chopsticks' before the rehearsal began.

In the warm days of early September – still basking in the freedom of the summer holidays and reluctant to return to scheduled playtimes – preparations for the harvest festival would begin. Old hymns would be rehearsed in schoolrooms plagued by disoriented wasps, who were always particularly angry at this time of year and would throw themselves repeatedly against the windows in a bid to escape the curled workbook of a teacher trying to alleviate our being distracted by the small creatures. Come November, the chords of Christmas hymns would resound through the single classroom, which was divided in the daytime into two by an accordion partition, only becoming one large room for rehearsal purposes. Whereas harvest festivals took place in St Mary's church (chosen dwelling of the bat population), our Christmas concerts always took place in the small, Methodist Capel y Gro at the edge of the village. I attended a few rare Sunday schools here but the Christmas concert each year was our only consistent acquaintance with the chapel, which I would therefore always remember as being extremely cold. Although the smell of a great many electric heaters filled the nave on the dark December evening of our nativity each winter, to endure the entire Christmas concert – without entirely losing the feeling in your fingers – it was necessary to cradle a hot water bottle

on your lap, smuggled in beneath your winter coat. In spite of the cold, there was always something magical about the hum of 'Ar Hyd Y Nos' as it concluded the Christmas concert. Grandmothers wrapped in padded jackets and shawls joined in with an unwavering majesty, as grandfathers dressed in tweed jackets and checked brushed cotton shirts would stand, lending their baritones as accompaniment to the light, piping falsettos of our childhood voices. The parents always seemed a little more hesitant, but it never really mattered: the sound of a chapel filled with voices was one of home, of childhood.

———————◆———————

Occasionally, we find ourselves singing through a few of those old nursery rhymes and school songs as we work outside at the vat. Our arms are elbow deep in the warm liquid and beams of light slide through into the woodshed, catching particles of wood and wool and dust in their paths. The resist-dyed pieces are growing in their complexity, showing abstract rice-paste geographies that require careful dipping. We hold them tentatively beneath the surface of the warm liquid, anxious not to smudge the rice paste between our fingers.

Our voices are soft and flickering, humming along forgotten verses and easily losing track of where we are.

They're the same kind of short, half-remembered tunes you might hum whilst waiting for the kettle to boil or a pan of oats and milk to thicken into porridge – processes which seem to suddenly slow the entire world around them. By now, my mum is approximating the minutes of each dip on her own internal timepiece, employing a far more lenient methodology than she had done in the first weeks of the summer, when we had dutifully counted the seconds of each immersion in the vat.

There is a great sense of purpose: to wake up each morning and head straight out into the garden, pull the thick lid from the vat and spend the day dipping and re-dipping damp cloth. Each day, we watch the milkiest wools and linens turn a deep blue. My mum's understanding of indigo is deepening, her working process becoming more fluid. As I take part in these daily ceremonies beside her, it seems completely natural that making can alleviate depression. My mum may have come to indigo dyeing from a place of grief, but there is no sense of despair in the way she works.

University College London and BBC Arts conducted a study in 2018, which found that any amount of creativity, regardless of skill-level, had positive impacts on people's stress levels, confidence, self-esteem and ability to problem-solve in daily life. Creativity can help us express that which is difficult to say in words and it can also

repair parts of us that no medical diagnosis would find to be broken.

————◆————

Botanical drawings painted against ink-black wool are suspended in rows along the entire garden, on bamboo poles, stray branches and our old washing line kept aloft by an ash branch firmly wedged into the lawn. Symbols of my mother's grief, but also of her healing. Caught by the sun, the lines of the saturated rice paste shine a metallic blue-green and the sound of dripping indigo sings against the ground.

I watch as my mum dips and re-dips pieces, over-dyes and cuts up others. We eat lunch surrounded by dripping indigo as she slowly and subconsciously considers each piece. It is an intuitive way of working, a chess-like process in which she contemplates how to move forward with or realise an idea. She is constantly in motion, moving quickly to keep up with thoughts or solutions as they arise in a ceaseless state of flow. The work will not heal the loss of her father completely, but her absorption in the practicality of the making process has alleviated the immediacy of sorrow.

Chapter 6

A Blue House

A little while after midsummer, a travel bag sits empty and waiting at the centre of my bed. Packing has always seemed to me an extremely daunting task to be avoided at all costs and I spend a few moments poring over a small list I have made of essentials before agitatedly casting it aside and folding into the bag a week's worth of underwear, a small pouch of toiletries and a couple of clean shirts. Zipping the bag closed, I go downstairs and deposit it next to my mum's canvas backpack in the doorway. She's sat at the kitchen table, finishing a cup of tea. Once her cup has been rinsed and turned upside down to dry on the draining board, we leave for the train station in Chester where we'll say our farewells to my dad before making the three-hour journey south.

Although we announce to all who enquire that our almost annual trips to London are made in the spirit of seeing exhibitions at the Tate, Serpentine or National

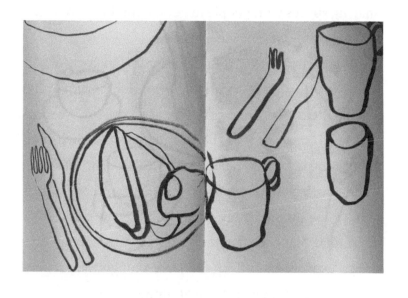

Gallery they are more truthfully, at least partially, made in order to sit in cafés and bakeries. The ceremonials of coffee – the click of a portafilter being slid into place; the trickle of golden espresso hitting a tiny white cup and chorus of teaspoons stirring sugar and foam – are soothing and beautiful in their ordinary and everyday-ness. To me, it feels like what good city life is about. Sharing spaces with people in gentle, unobtrusive ways. Sipping coffees alongside strangers.

Whenever I find myself saturated by ideas, work or whatever it is that is occupying every inch of my mind to the extent that none of it has any space to become realised – I travel. It could be half an hour into town or an hour to the coast but ideally, it's a week (or more) some-where further afield. Somewhere just familiar enough that you're immediately comfortable but sufficiently unfamiliar that each day presents you with enough new things to push out all of the stale thoughts that were taking up space in your head at home.

This is a technique my mum taught me. We'd practise it on a small scale when I was younger, taking trips into town for cups of tea when we found ourselves frustrated. In my late teenage years, if a trip to a nearby town wasn't cutting it, we began turning to London. If I was struggling to break through the purpose of my essays and making paintings that felt rehearsed and overdone

or if my mum had been drawing the same things for too long and had grown tired of observing the same lines and shapes, then we packed up and left. Sometimes for the afternoon, others for the week. It was a way of resetting / resettling our minds.

———————◆———————

The trains down to London are always too warm, especially in the summer. I drop into an uncomfortable half-sleep as we roll south, jolting awake whenever I sink too deeply into a blurred dreamscape. Across the grey plastic table, Mum pulls out her reading book and we make the journey mostly in silence, occasionally communicating to draw attention to something out of the window. I make the wobbly journey up the train to buy a cup of peppermint tea and a bottle of water and return to my seat feeling completely drained by the experience. However, the changing landscape beyond our window revives my spirit as we begin to quietly discuss what we will do on our arrival, exhibitions we'll see and friends we'll meet in the coming week.

The train pulls into the platform and we disembark, navigating a path through the station hall crowds who stare blindly up at the electronic glare of the departures board, unblinking expressions fixed on

the shivering yellow lists as they move leftwards along the screens. Outside, the air is warm and thick with pollution but there is an undeniable thrill, which comes with being in a city after a life spent in the country-side, that briefly ameliorates the filth and noise of the concrete metropolis.

———————•◆•———————

We make a detour on the way to the friend's house where we'll stay, walking down into Covent Garden to visit a tea shop we seek out whenever we are in London. It's a small, unassuming shop with a black and red façade that has been here since 1982. Hand-painted lettering on a small square sign overhanging the street reads: The Tea House. My mum discovered it when she was at art school and – according to her – it has changed relatively little since. Dark wooden shelves line its interior, stocked with small black packages of tea leaves wrapped with carmine labels. There is a subtle, musky smell of cedarwood and bittersweet sencha. We fill a small metal basket with Nepalese black tea from the foothills of the Himalayas, Keemun and a bag of spiced masala as a gift for the friend who will be hosting us. We pay and safely stow the tea in our travel bags before walking up through Seven Dials towards Islington.

Along Monmouth Street, I notice a man place a pink, plastic ice cream spoon on top of a bin. The action strikes me as rehearsed and purposeful, rather than the simple discarding of a tool no longer required. It seems odd, to not have simply tossed it into the bin. For the rest of our afternoon journey walking across London – and in fact over the week as a whole – I slowly compose a fragmented and somewhat incoherent story in my head of his life leading up to the incident and the events which followed. I endow the plastic spoon with special significance, its placement a message from one person to another, that they should meet in the pre-agreed place, at the mutually understood time. I never quite settle on the reason for their meeting, my imagination is too preoccupied with the visual elements of their story: a lunchtime exchange in the empty, green-tiled fish and chip shop we pass around the corner. An early evening reconnaissance in the sombrely lit, burgundy interior of an operatic café in Clerkenwell, mutually surveying the street outside beneath the rippling, final note of *Madama Butterfly*, its uncertainty washing over the scene, as they quietly discuss their undefined business. Each time my eye is drawn towards a quiet corner, a busy Underground entrance or emptied room in the British Museum I imagine meetings between secretive strangers; quiet and discreet, easily hidden

beneath the continuous roar of the city. I have always romanticised London in this way, existing within it as though it were a film scene or book passage. I still do this, even in the time I've lived here. Perhaps it is my hillside and hedgerow way of trying to understand why anyone – including myself – would ever live in this city.

———— ◆ ————

Along the slope of Copenhagen Street from King's Cross, the late afternoon sun casts long blue shadows out across the road. We reach the house, which is tall and narrow and beautiful, its elongated facade reaching up five storeys and looking out over a small green square, its front door painted a dusty artichoke. We ring the bell and the distant sound of footsteps answers before the door opens with a short electronic chime of the alarm system. I think fleetingly of how many times we've slept with the front door wide open in Wales, having innocently forgotten to close it after walking to and from the garden all day. Once the postman came into the kitchen, parcel in hand, to let us know we'd done so. Another time, a neighbour valiantly climbed into one of our upstairs windows for us and let us back in after we'd locked ourselves out when going for a walk – a particularly impressive feat given he was in his seventies at the time.

Dressed in shades of indigo blue and with dark, shoulder-length grey hair, our friend Jenny stands in the doorway of the tall house, welcoming us for the week. We enter the hallway, which is lit by a thin passage of light travelling from a window at the back of the house, providing a glimpse out onto the long, slender garden beyond.

The garden is a verdant tangle sheltered beneath a gnarled crab apple tree. Outside the glass balcony at the back of the house, dripping green branches are twisted into an arbour that leads into the garden and down to a small studio, built from dark sheets of corrugated iron, nestled at the far end. Bouquets of ferns spring from between the paving stones and everything is trickling with moss. I didn't know at this time, that it would be inside this studio shed that I would write many of the pages in this book, distancing myself from the Welsh landscape momentarily, in order to better reflect upon it.

Sometimes it is only with distance that we can truly appreciate the everyday, the simple pleasures of walking across fields or over hillsides; of being a car-ride away from almost everything that could be considered busy or hectic. The rush of the city provides the perfect distraction from almost anything, though perhaps to the extent that all else is forgotten. Weaving through the crowded streets, between buildings and people and queues and

cars, there is a sense of time passing unreasonably quickly: entire months slip past in moments. The seasons are a kind of background accompaniment to life, with little effect on it beyond migrations to outside tables at pubs and cafés.

In London, I tend to lose myself in patterns of opportunity, work and exhaustion. The urban expanse presents itself to me as a seemingly limitless pool of potential, in which I could do anything I wanted. However, the reality is that I become too tired to remember what it was that I'd wanted to achieve in the first place and flounder for months, sometimes years, unsure of what brought me here to begin with. I have to return to the quiet of the countryside in order to remember the joys of the city and, likewise, must spend time in the city to appreciate those of rural life.

———— ◆ ————

The rooms of Jenny's house articulate a life in objects – telling the story of a life rich with creativity. Small, carefully considered assemblages held inside drawers or on shelves take on the role of autobiographical fragments. The bookcases in her living room are filled with art books and postcards poke out from between their spines like peculiar leaves in a hedgerow. In

between the bookshelves, there is a mirror haloed by a sunburst of feathers, each collected from a particular place of importance or gifted by a friend. Amongst the long reddish-brown pheasant and snowy-white barn owl plumes there are a couple of cheerful green ones from the ring-necked parakeets who have made London their home, and whose chatter oscillates across the pink evening outside as they gather to roost.

Her decoration of the house is carefully considered and yet completely organic, delicately changing in the time between our visits. This summer, I feel as if I see it only in shades of blue. Small details and objects I hadn't noticed as clearly on previous visits, or which had arrived in our absence, leap to meet my gaze: the slate of a series of pencil drawings hanging in the living room, their blueish lines turning silver in the afternoon sun; the softened indigo linen napkins we use at supper; the zinc countertop in the kitchen, splashed white in places by the sink; a length of roughly woven blue fabric patterned with shimmering white lines cascading down a bedroom wall. Enquiring about this last object, we're informed that the indigo fabric is an *ndop* cloth, made in the grasslands of Cameroon, and bought in Paris.

The cloth is stitched together from panels of fabric and the technique reminds me of the blankets my mum started stitching together before we left. Made using

grass-tying methods, the lines of the *ndop* cloth are softer than the bold, hand-painted drawings of her blanket pieces and the depth of the dye is much lighter but there is a kind of distant connection between them, as exists between all indigo cloth: an ancient quality which imbues even the most modern of dyed pieces with a sense of being connected to much older craft traditions.

———•◆•———

We drink tea in the living room, relaying the events of our indigo summer and my mum's trip to Japan. The window of the room looks out onto the street and a thin sheet of tracing paper has been pinned across it. Over time, Jenny has sewn and taped this sheet with translucent, pressed leaves that are now sun-bleached from their window exhibit. We sit and sip cups of gently sweet masala chai, slipping away momentarily from the tumultuous city beyond the front door into another world of indigo conversations and objects brought forth slowly and naturally over the course of the afternoon.

Conversation turns to Japanese textiles and to the visible mending technique of *boro*, the term given to mended or patched textiles from Japan that comes from the word *boroboro*, meaning something tattered

or repaired. A craft of necessity, *boro* arose from the traditions of rural peasant women who repaired tears in their family's work clothes using whatever materials they had to hand. Striped fabrics and woven patterns were layered with both the palest and the deepest indigo cloths. Many patches were applied using *sashiko* stitching, a reinforcement stitch literally translated as 'little stabs', which quilted the cloth and strengthened it for future wear.

Whilst we are talking, Jenny produces a pair of carefully mended indigo *jika-tabi* slippers she'd recently been given by a friend. They are made from deep oceanic blue cloth and repaired in places with tiny pale *sashiko* threads. The dye has faded into gentle cloud formations along the heel and toes, conveying another distinctive quality of indigo: as it ages, the colour lightens but never disappears. The indigo we had become familiar with over the course of the summer so far had been freshly dyed; dark, steady blues. However, over time these fabrics disclose their histories, fading and softening in infinitely inimitable ways with use and wear.

———————◆———————

Mum and I share a bed at the top of Jenny's house, with two large Georgian windows veiled by oatmeal linen

sheets. In the morning, the sunlight seeps through the open weave, and they glow in two silver pillars against the shadowed plaster walls. We take turns going downstairs to make tea. Sunlight filters through linen and raffia blinds along the stairs down to the kitchen, which is completely quiet, save for the muffled sound of a radio conferring the morning news upstairs. The climb back up with two full cups of Earl Grey in the mornings is treacherous, particularly if you're still wearing thick bed socks. The stairs are the kind of slippery, well-worn wood that melts into air whenever you lose focus for a moment and I've found myself having to mop many milky puddles from them over the years.

After drinking our half-emptied cups of tea in bed, we have breakfast down in the light-filled balcony area at the back of the house, looking out onto the dew-sodden garden not yet sipped by the sun. We eat porridge topped with pears from small bowls brought back from Bologna, whilst piecing together a plan for the day ahead. Our days in London tend to organise themselves around a visit to a particular museum or exhibition, followed by time spent in a nearby café, digesting what we've seen over coffee afterwards. In the evenings, we sit in Jenny's low-ceilinged kitchen after dinner, eating mangoes that come in bright cardboard boxes. The fruits are tucked in with pink and yellow wrappings and I save a few

for collages, hoping that their brightness will remind me of the summer when I finally sit down to use them in the dark cradle of autumn. As we finish breakfast, light steadily tumbles through the branches of the crab apple tree and a thin film of mist hovers above the green, signalling the beginning of the day.

———◆———

The apparition of inspiration is unpredictable, but I find it often arrives over coffee. So, each day we walk to a new café. A Finnish bakery with heavy mugs of filter coffee and cinnamon buns; a collection of wooden chairs haphazardly arranged on a quiet Bloomsbury street with coffee served from a hatch; a Moroccan garden tucked away in Belgravia. Each is different but the coffee is always good.

The *caffis* I grew up with had mugs of dark tea and even darker instant coffee. Sugar cubes, which had very possibly been there since the 1970s, gathering dust on the tables. Milkshakes the colour of Barbie accessories. They served fat slices of Welsh rarebit and baked potatoes filled with tuna mayonnaise and were frequented by an ageing population, with wheeled shopping trolleys parked out front. Their owners inside, spending hours perusing the local paper and exchanging gossip like

chickens clucking competitively over grain. Every once in a while, a *caffi* would undergo refurbishment and its old wooden tables and chairs would be replaced with tall, glass piazza tables and high stools, or stainless-steel counterparts etched with chequerboard patterns. Regardless of how the interiors were updated over time, they would always remain wrapped in an air of nostalgia.

Lattes arrived somewhere around my graduation to secondary school and were served in tall glasses with tiny handles just big enough for one or two fingers to loop through. Cappuccinos the exact same but with a shaking of powdered hot chocolate on top. The coffee tasted of very little, a distant bitterness disguised behind scalded milk, but there was something special about these foamy concoctions; they became an end-of-day treat when my mum picked me up from school or a doctor's appointment, sometimes accompanied by a crisply toasted teacake served on mismatched china with rectangles of butter wrapped in thin yellow foil.

My mum and I talk about cafés she visited in Japan: a coffee stand at the edge of Yoyogi Park where she'd sat and read one afternoon; a Korean restaurant with a birch interior where she'd eaten brown rice balls wrapped in seaweed; and a café specialising in pineapple cake, which was in the shape of a bamboo basket. As we talk, I draw the table in front of us: cluttered with half-empty

coffee cups, water glasses and golden crumbs, absent-mindedly collecting our trip into my sketchbook to take home. Over the course of the week, we each build a small archive of line drawings depicting moments in cafés, museums, markets and artefacts found in Jenny's house to remind us of thoughts, ideas and experiences on our return home.

———— ◆ ————

Halfway through the week, we pass the British Museum on our way to Cornelissen's art shop. Seeing that it looks quiet, we wander inside to briefly escape the midday sun. The midweek museum is a special thing: cool and peaceful save for the occasional school group passing through en route to gaze at the encased pharaohs, their fingertips leaving misty prints across the glass. Otherwise, the soft echoes of footsteps against marble and the whisper of pencil against paper as we sketch remain generally undisturbed. Following the grand south staircase upwards, we bypass the chiming room filled with clocks, before settling amongst the cabinets holding stone and ceramic artefacts from Mesopotamia. We remain there for a while, enchanted by strings of lapis lazuli and carnelian beads and ostrich eggs inlaid with grey-blue stone alternated with mother

of pearl, before climbing the stairs to the Japanese Galleries. There is no indigo cloth up here, but we find its colour in the woodblock prints showing azurite temple rooftops, ink-blue depictions of Mount Fuji capped by pale snow and the patterned blue *hippari* jackets of workers in flooded rice fields. We stop and buy a small collection of Hokusai postcards on our way out. Some we'll forward to friends and a couple we'll keep for ourselves tucked into sketchbooks or pinned to the kitchen wall.

We had hoped to find more pieces of indigo inside the British Museum, but there were none on display. Much of the indigo cloth held at the British Museum, like 99% of its collection, remains in storage. However, its catalogued indigo items tell a story of a colour that is spiritually, economically and culturally important across the world. It has been used to dye the linen of a late-nineteenth-century wedding coat (*jillayeh*) from Galilee and stitched into an embroidered portrait of the Buddha from eighth-century China, whose indigo hair remains a deep blue-black whilst all the other threads have faded. It is twisted into Peruvian bags and *quipu*[8] and is the colour of the intricately patterned *adire* cloth

8 *Quipu* are recording devices fashioned from strings, historically used by a number of cultures in the Andean region of South America.

from Nigeria, of which there are hundreds of pieces in the museum's hidden collection.

Their absence from display reminds me that the British Museum's existence is knotted together with colonialism and disputes of ownership. The curation of these artefacts inherently accounts for the inclusion – or exclusion – of particular objects and histories whilst demonstrating distinctly European understandings of value, purpose and interest. Though their vast collections can be limitless resources for both study and inspiration, their retention of stolen items casts an undeniable shadow across our visit and we don't stay long. I'm reminded that the history of indigo is equally tangled in the roots of colonialism. The production and export of this dyestuff was a cornerstone of European colonial empires. Dyers from West Africa – possessing ancient knowledge of growing and processing indigo – were enslaved to colonies in the Americas and slavery was in fact legalised in the state of Georgia solely for the purpose of supporting the indigo industry. Today, there are a number of dyers in West Africa reviving the dyeing practices exploited by colonialism, including Nike Davies-Okundaye and Aboubakar Fofana, who are reclaiming and redefining their indigo histories.

———◆———

We bring the absence of displayed *adire* textiles up on our return home that evening and Jenny tells us of a trip she'd made to see her sister and brother-in-law in Nigeria in the 1970s. They had visited the indigo dye workshops at Kofar Mata in the north, photographing the deep blue-black vats buried in the ashen ground. The workshops were those visited by Tuareg nomads, known colloquially as the blue men of the desert; their robes a faded black against the dunes and stone plateaus of the Sahara and their skin stained by the dye.

Adire is the name given to traditional resist-dyed indigo cloth from Nigeria. In Yoruba, the word translates as *adi* 'to tie' and *re* 'to dye', and refers to textiles that hold patterns applied both using cassava paste or by tying raffia against the fabric. Like the Japanese rice paste my mum had been making, Yoruba cassava paste is a thick yellowish glue that can be painted onto fabric before it is immersed in the indigo vat in order to resist-dye pieces of cloth. It is also a similarly slow and laborious way of producing textiles, meaning that the practice is highly valued but also that it decreased with the development of industrial dyeing techniques. Each *adire* pattern is named, some are even given multiple names. In this way, the inimitable quality of each piece is both recognised and celebrated whilst also delineating the inextricable connections between maker, process and

product in contrast to the anonymity and exploitation of contemporary textile production.

Jenny tells us that somewhere, perhaps stowed away in a chest in the attic, there is a piece of *adire* fabric she has called Little Moon, with a rounded resist-dyed pattern across a blue ground, but its whereabouts could not be determined and so we each dream of imagined night skies falling over openly woven cotton and each of our visions is different.

————•————

We magnetise indigo and the stories it conjures. Our tea-time conversations with Jenny over the course of the week always seem to wind back to indigo and where we might see more of it whilst we are in London.

Together, the three of us visit Spitalfields Market in our search for more fragments of the dyestuff. It is a crowded Thursday and the sellers wander between stands, exchanging slivers of gossip in between sales pitches to browsing customers. The smell of coffee and breakfast rolls drifts through the market hall, making me feel hungry and nauseated in equal measure as it mingles with mothballs and old metal.

We pass steel-framed stands draped in the muted technicolour of sun-faded woven textiles from West

Africa, their modular compositions incorporating dark blues that could well be indigo between eggshell, burnt orange, walnut and ochre. Alongside these there are stalls dripping with heaped piles of costume jewellery glinting in the sunlight that falls through the lantern roof and tables spread with tiny artefacts that look as if they have been trawled from the bed of the Thames – indistinguishable pieces of oxidised copper and iron with paper bags alongside to collect them into, like pick-and-mix sweets.

Like any good antiques market, the interior speaks to years of hoarding and appeals to my tendency to acquire useless yet interesting things. Turning a pretzel-shaped charm in my hand from a bowl filled with brass amulets, I notice the patchworked blue of a rail holding a line of old French linen nightgowns. Each is slightly different, dyed from the softest cerulean to a dark indigo. I select a pale cornflower one from the rail, holding it briefly up to my frame in a mirror leaning against the steel corner post of the stall to check the length. I think to myself that it was probably a child's dress as I am only five foot and it looks a good length, although perhaps it's actually just from a time when people were smaller. I unfold a £10 note and the seller deftly tucks the dress into a translucent blue plastic bag before returning it to me.

My mum is nearby with Jenny, rummaging through a basket of linens, looking for pieces to dye on our return to Wales. Once we each have a colourful bag filled with cloth treasures, we make our way out of the market, stopping just once more at another French stall to buy a few thick glass jam jars.

———— ◆ ————

Towards the end of the week, we find ourselves crossing the scorched ochre grass of Hyde Park, following the turquoise glass of the Serpentine with its angular form that somehow clashes with our understandings of bodies of water. It is strange to think that this space was once meadows and the roaming grounds of deer, boar and wild bulls. The Westbourne stream that flows between Hampstead and the Thames is now buried underground but it once wove across this land, providing water for the animals that grazed here.

We sit for a moment next to the anthracite pavilion outside the galleries, its form reminding me of the catching pens used to collect sheep together for shearing, or the dark metal grid of a cattle gate. I close my eyes, imagining the rush of water beneath our feet, thinking of the stream which runs through our Welsh village. The amber glow of the sun through my eyelids and the

park's cacophony remind me of schooltime summer breaktimes lazing on the playing fields covered in the dried hay of cut grass, always slightly conscious that a football could plummet from the sky at any moment. I find the city characterised by a similar tension between peace and unease, as if moments of rest and quiet are always temporary; only to be experienced with the half-conscious knowledge that the commotion of the urban will shortly resume.

We cross the park, following the course of the subterranean stream towards Belgravia where we seek afternoon shade in a blue-tiled garden at the back of a chocolate shop. Eating dark chocolate sorbet, we slip our shoes off under the table to soothe our feet and sit for an hour or so before making the long bus journey back to the house in time for supper. My mind wanders to and from an idea of the clandestine rivers of London, imaginarily mapping them out as glowing veins across the city. That evening I search the internet for such a map: tracing the River Fleet down from the northern city ponds to the winding Thames at the centre. I recall the sweeping curve of a Bloomsbury street we had passed on our route to the British Museum a few days before and realise that this curve forms the boundary line between Holborn and St Pancras, which had once been divided by a flowing brook. I find myself gripped

suddenly by a feeling of estrangement. The edges of the city slam up against me in a sharp clamour of noise and pollution and heat, and I suddenly feel claustrophobic even in an empty room. The chasm between the winding, organic courses of nature and the regimented construction of everyday life in the city unnerves me. Despite my yearning to sip dark coffee on street corners or inside airy bakeries filled with the caramelised scent of baking pastries, my body aches for a return to the unpredictable geography of sloping fields and craggy mountainsides. A restoration of a kind of silence broken only by the trill of blackbirds stealing berries from the garden, rather than the distant wail of a siren.

———•———

As we board the train at Euston the next day, I am reminded that our pastoral life, such as it is, could not exist without the city. The harsh winters, which must be prepared for with electric kettles and powdered milk in case of a snowstorm preventing oil deliveries or food shops, are made bearable with the thought that momentary escape is possible with the defrosting of the roads in the spring. The changing of seasons, blooming of hedgerows, sudden appearance of swallows and the glow of autumn become all the more beautiful when

you look away for a moment. It is easy to become desensitised to the wonder of nature as it bursts into life around you, just as it is easy to lose oneself in the chaos of the city and forget the marvels of watching year upon year pass in the quiet, continuous cycles of the seasons. The daffodils blooming from buckets along Columbia Road are no real substitute for the bursting yellow banks of a country lane in spring.

Spending a week ensconced in the concrete and noise of London provides the catalyst for new thoughts to form. To remove oneself from familiarity for a moment allows ongoing projects to be reflected on from a distance, and for a renewed appreciation for the quiet of Wales. Providing a much-needed break from working patterns so that we can return to them with fresh eyes. By the end of our sojourn, there is a shared readiness to return to a slower, rural existence – where we must make our own coffee but also where the night skies are a deep blue rather than acid green, the blinking crimson lights of aeroplanes restored to stars.

Chapter 7

Collections

The heavy glass jars from Spitalfields sit in a line along the middle of our kitchen table and Mum drops a small tealight into each, ready to be lit at dusk. The windowsill holds other treasures from our trip: a small bronze bell covered with a thin layer of amber rust; two spools of blue darning wool from a knitting shop in the Camden Passage; the small paper bag containing Hokusai postcards from the British Museum.

Overlooking this, the wall to the right of the window is covered in a collage of postcards, each secured with a small piece of washi tape. There are a few other artefacts interspersed among these, each holding their own autobiographical narrative: a delicately illustrated envelope from a calligrapher friend; a collage I'd sent with a letter written on the reverse; a small print made by my sister in her final year at Glasgow School of Art; a photograph my mum had taken of my granddad in a dusty old shirt

and braces. Watery blue eyes and dirt sticking in the lines along his face. I can remember the day she took it, we had been building a bonfire; a huge pyre of garden waste with tangles of ivy, brambles and trimmed elder branches. It was the summer before he'd passed away and we'd spent almost every weekend with him, doing whatever garden tasks he assigned.

Collections have a powerful way of reminding us of things put to the back of our minds or forgotten entirely. Why do we save train tickets, certificates, small trinkets and seemingly useless objects if not to hold on to the moments in which we acquired them? They can retell stories and recall moments of inspiration.

———•———

For as long as I can remember, my mum has collected things. I've always understood it as another aspect of her artistic practice. The desk in her studio is often laid for an unusual soiree, with chipped ceramic side plates holding stones, shells, tiny pieces of driftwood and sea glass. There are pressed flowers, pale and paper-thin, collected into heavy books on art and botany, which are assembled in stacks around the desk. Hagstones with hollow, sea-worn bellies are balanced along the chimney ledge at one end of the room. Each of these

disparate objects is bound together by a single shared commonality: they possess something she'd felt inspired by in the moment and through saving them she preserves something of that feeling.

I suppose it was inevitable that I, too, should become a gleaner of all that charms or momentarily catches my attention. In my first year at university my windowsill held a line of empty sea urchin shells collected along West Sands, their brittle greys turning slowly white in the sunshine. The walls were pinned with pressed leaves that my mum enclosed in her letters: trefoil figs from a small potted tree outside of our front door; tiny auburn oaks from autumn walks along our familiar route through the woods and along the fields; the purple heart of a forest pansy found when she'd visited Jenny in London.

The ceremony of collecting things along a walk is similar to foraging food in many ways. Both practices leave one in a state of being constantly on the lookout for new things in familiar environments. In return for close observation, you are granted a sense of being alert to the changing of seasons as they happen slowly but surely each day.

We walk every single day and have done so for as long as I can remember. It is another piece of my inheritance, another ritual passed along by my mother. As children, my sister and I oscillated between joyful muddy walkers

and sulking weights demanding piggybacks but now, as adults, we continue the routine irrespective of whether we're together or not. There is something about being in the open air that revives you. It clears the chaotic hum of thoughts that seems to swell in my head overnight: the emails I need to send; phone calls to make; messages to respond to; that dentist appointment long overdue or the thank-you note I'm yet to send. They settle into some kind of amicable order once I've managed to forget about them for a moment, and walking seems to grant me just that.

———— ◆ ————

There is a kind of childlike joy in collecting things as you walk, a delight in looking. Alongside the physical objects – acorns, oak galls and whisps of sheep's fleece – I realise that I am also collecting a language with which to describe the world around me.

Collections construct unique vocabularies. They are a way in which we make sense of the world and remind ourselves of places, people and feelings once we are elsewhere. Personal collections can act as windows, through which we can glimpse another's world. They are small fragments, which contain aspects of our individual worlds and histories, compendiums to our experience

and vision. I invariably find myself gathering a small token from each place that has ever felt special: a postcard from a rack outside Canterbury Cathedral; a silver-chained memento from the Feria Market in Seville; a thumb-shone conker from a walk around Powys Castle which resided in my coat pocket for months before being placed on a window ledge at home. I did the same as I walked through my granddad's house after he passed away, looking for things that I could hold on to in his place: a couple of jumpers; a blue plaid jacket; his shooting hat. Yet I never wear any of them, I don't even look at them. Instead, the most precious thing – possibly the only thing that will survive long-term as other objects are slowly lost to moves and moths – is a tiny sketch of his cottage he'd made on the back of an envelope. He had built an extension onto the cottage at some point and wanted a drawing made of the original house. When I was sixteen, he knew that I was steadily following in my mother's footsteps and becoming an artist, so he'd quickly sketched the outline of the original cottage for me to use as a guide. I was so terrified of disappointing him that I never began the project, but I always held on to the drawing he'd made, treasuring it alongside a tattered pink envelope that holds my great-grandmother's handwriting.

———— ◆ ————

In his profile of the artist Lenore Tawney in a 1967 issue of *Craft Horizons*, the poet James Schuyler reflected, 'Often, the place where an artist lives is remarkably like the work that is made there.' Although the collections in my mum's studio may not have an obvious relation to her work, their influence is undeniably there. The gentle blues and greys of the stones arranged along the chimney ledge of her loft studio can be found in the soft lines and charcoal of her early landscape drawings characterised by curving, weatherworn hills. The organic lines of the leaves and pressed flowers along her desk and encased in books have suddenly found their place in the natural worlds that now fill her sketchbooks. Although the connections may not always be clear or immediate, a bond between the small artefacts she surrounds herself with and the work she is making has always existed.

When I ask her about connections between the collections of things she keeps in her studio and her work, she replies that she isn't always sure why it is that she is collecting something, just as she's not always sure why it is that she's making something. Sometimes, there are long periods of gestation when she is collecting

a particular thing as it inspires her in some way and yet she doesn't know how it will ultimately influence or feed into her work. There is an intuitive element to both processes and the results are equally and inherently unpredictable.

Her approach to collecting, as with many artists, stands apart from the commercialised hobby culture that originated in the 1950s. The collections themselves have not been consciously formed but rather emerge over time, often composed of things of little or no economic value. For a long time, she collected old seed packets, labels, envelopes and button cards. They sat in untidily gathered stacks tied by blue elastics, inside shoe boxes or on the desk in her studio. They remained this way for years, tucked away but ever-growing in number, until one day she began to draw on them. These seemingly useless by-products of useful things – labels, leaflets, envelopes and button cards – were suddenly transformed into a piece of work. They became the canvas for a series of line drawings of whisks, salad spinners and tea strainers, their randomness and variety unified by the simplicity of the dark ink lines against a patchwork of colours and advertising typography. I am struck once again by her sense for the value of everyday things, an appreciation for the simply coloured cards that held spare buttons for our school cardigans, the hooks and

eyes of her grandmother's sewing box, the tag from a toy bought at a jumble sale.

———— ♦ ————

When I first left for university, my mum's drawings had been observing the lines of the two rows of kitchen utensils that hung at either side of the Aga. Spindly contours of whisks, sieves and vegetable brushes rendered in delicate lines of Indian ink that bled through the paper of her sketchbooks, creating ghosts of the drawings on the following page. But, in the time that I had been away, she had started to fill sketchbooks with indigo tempera drawings of plants and flowers, leaves and seed heads from her daily walks. I watched as the pressed flowers and illustrated botanical guides from her studio slowly emerged as sources of inspiration for her work with indigo.

The florae she had collected and pressed were all connected to a personal geography. They mapped out the daily walks she made around the hills, woodlands and fields that composed the parameters of our village. For the majority of my school years, she had walked these routes alone each day but during my sixth-form years I was often at home, and we began to walk them together. It was along these walks in my late teenage years that she

stopped simply being my parent and became my closest friend. Perhaps there is something important to be said here for giving time to your parents, by which I mean time beyond that which is unavoidable. Their roles in my teenage years had been those of boundary setters, ever preventing my social success, but as I moved towards my twenties, I somehow found a foothold in a new sort of relationship, a gentler and more balanced kind in which a deep friendship – the type that comes from having known these people my entire life – could form. In the hours when I could have been spending free periods with friends or catching up on work at school, I instead took daily walks along the fields with my mum and spent afternoons baking or catching up on coursework next to her at the kitchen table as she worked. They were years spent in unhurried conversations about everything from why we make art to how best to substitute caster sugar in a recipe. It was an opportunity to more deeply know this person and in return she granted me an insight into her own way of engaging with the world around her: through collecting and making things.

Her own mother had left when she'd been a child and she'd been brought up by my granddad and his mother. I think because of this, our friendship runs even deeper: it is that mother–daughter relationship she'd missed out on and is even more precious to us both because of this.

On these walks, she always encouraged me to engage with the landscape, not to merely walk through it but to notice slight changes in each day: the freshly trampled threshold of a badger sett, the river height fluctuating with bouts of rain or drought, the abundance of pheasants in the autumn and tadpoles in the spring. In calm weather you could hear the life of the forest: the quiet scurrying of feet or the rustle of wings. Other times, the wind was so fierce we had to brace ourselves against it, walking in silence with scarves wrapped over our ears, wordlessly taking note of things we noticed along the way.

Perhaps the loss of her father impacted me more deeply because of this closeness than it would have done had our relationship been more distant. I felt completely unravelled by his death, not only for my own sense of loss but for the profound way I also felt hers. Now, as I watch her dyeing with indigo and witness her focus return after eighteen months of searching for inspiration to work, I share the same sense of being uplifted.

———•———

Amongst the letters, drawings and postcards in my mum's kitchen are a black-and-white photograph of Barbara Hepworth in her Cornish studio carving a pearl

of luminous wood, two orbital gouache paintings by Sonia Delaunay and Leonora Carrington's *The Giantess*. These are the women who watch over her as she works. Women who continued to paint throughout motherhood: balancing family life with artistic practice. Women, like my mother, who had refused to allow the pressures of raising children and homebuilding to curtail their practice, instead allowing these elements of their everyday lives to feed into their creative work. Delaunay's quilt made for her son in 1911, a cubist composition of colourful cloth now in the collection of the Musée National d'Art Moderne in Paris, illustrates the inextricable worlds of art and life, perhaps especially for mothers, who have historically spent far more time working within spaces of domesticity. It also speaks – like our school shoes hand-stitched by our mother with after-school tales relayed over tea and toast at the kitchen table – of a particular sensitivity with which the work of women artists can understand, navigate and represent themes of motherhood and homebuilding in deeply personal yet universal ways through acts of creativity.

———•———

Pulling pieces of sodden wool from the vat in the late August sun, it feels like an eternity has elapsed since I've last watched the process of freshly dyed fabric oxidising from yellowish-green to deep sapphire blue. The initial colour of the fabric as it emerges from the liquid reminds me of the acidic night sky framed by the windows at the top of Jenny's London house.

We returned home from London lethargic in August's heat; a week of hard concrete and grit-packed breezes had sown a sluggishness in our bodies and we spent the first week at home in a kind of slow recovery, walking daily but doing very little else.

It takes a week, almost two, to resettle into a routine of working, but I watch now as my mum returns to her process with renewed vision. Although the process is familiar by this point, something feels different, the way she moves within it more certain. Around her, the garden sways with blue.

—————◆—————

There is a power to repetition. A kind of symbolism to a thought being re-thought and reconsidered, solidified. This is where I find a mindfulness in the act of collecting. It asks you to look at your environment in a more attentive way and in such a way, can help you to regain

focus in moments of distraction, anxiety or loss. Tove Jansson wrote in *The Summer Book* that:

> *Gathering is peculiar, because you see nothing but what you're looking for. If you're picking raspberries, you see only what's red, and if you're looking for bones you'll see only the white.*[9]

True enough, once you are looking, you'll find even the most familiar or mundane of walks along towpaths, park routes, woodlands or muddy fields will possess a thousand overlooked wonders. As a friend in Edinburgh recalled of her walks through the city during the lockdowns of 2020: once you learn the name of a tree, you begin to encounter it everywhere you look.

It is through going out and gathering a few small natural fragments from each walk to bring home that my mum sets her focus each day. Our walks and acts of collection become a kind of meditation performed daily between breakfast and morning coffee.

In Japan, there is a concept called *shinrin-yoku*, which literally translates to 'forest bathing'. It refers to time spent in nature, away from electronic screens, and

9 Tove Jansson, *The Summer Book* (London: G.K. Hall & Co, 1977), p. 13.

was developed in the 1980s as a form of treatment for the *technostress* that came with modern life. Research finds that practising *shinrin-yoku* can not only improve mental well-being but can also have physical benefits on the body's immune, cardiovascular and respiratory functions. Just as with creative practice, walking in nature encourages us to briefly shift our focus away from the things that are troubling us, allowing space in our minds to fully contemplate these things later. However, this only works if you really focus on the environment that you're in: if you notice the smells, the temperature changes as you climb through the woodland, the tiny unfurled cloves of wood sorrel that weren't there the day before.

Even when I'm far away from the Welsh fields we've trodden dirt paths along, I find myself unable to sit down to work before having been outside. At university in Scotland, these walks were generally accompanied by coffee and sometimes a pastry which disintegrated down my jacket as I stumbled up and along the banks of the coastal path in search of a glimpse of orange sea buckthorn or a few cornflowers for the table – the silver lyme grass whispering around me in the salt-laced breeze. There is an indistinct separation between land and sky along the coastline there. On overcast days, I would stop and allow my eyes to soften their

focus on the colourless expanse swallowing the entire world beyond the cliff path.

From the gorse-crested hilltop overlooking our house in Wales, you never lose the sense of being rooted against the earth but are met instead with a feeling of complete wonder at the limitlessness of the sky, and the patchwork of fields and woodland rolled out beneath it.

Chapter 8

Late Summer

Rain pelts against the house, bouncing off the windows in shards of silver. The garden sings with relief as a week of dry August heat concludes with a downpour. Sheltered under the eaves of the woodshed, we watch as water runs in streams from furrows along the corrugated roof. Together, we lift the vat further into the woodshed and begin moving the already dipped indigo cloth inside, too, protecting it from the rainfall. There are too many swathes of damp cloth to fit inside the small woodshed and the remaining pieces hang heavily in saturated lines between the willow and pear tree. Summer is nearing its end, though our dyeing work is far from done.

Mum darts up to the house, pulling from the porch the collection of umbrellas that has amassed there over the years. Some are vast, heavy-duty sails designed to keep a small huddle of people dry all at once; others are the rickety, short-handled folding kind that a gust of

wind quickly inverts, leaving you tense and sodden for the duration of your inclement journey. She deftly puts each one up and arranges them in a jumble between the trees, building a tent to shelter the freshly dipped cloth. Once she's done this, she runs back to the house and returns with two raincoats. We pull them on and continue to attend to the pieces we've already dipped as they'll need at least four or five additional dips each before we can abandon our damp posts beside the indigo vat. The rain is cold and hard against our hands, but submerging cloth into the warm vat is a gentle respite. The showers continue to roll in and out over the course of the day, broken here and there by soft rays of sunshine.

Rivers of blue don't course along the fabric as they had done in those first weeks of summer, but nor are there deep, uniform expanses of colour. I've come to realise that indigo doesn't produce flat, unrelenting shades of blue. There are soft gradations along the cloth, blues, greens and purples all dancing together. Some pieces have a kind of iridescence, a silver-like quality. Traditional West African dyers amplify this silver characteristic by hammering dyed cloth using wooden beaters in order to create a burnished surface. It is exceptionally unusual for two pieces of fabric – even if dyed on the exact same day and dipped the exact same number of times – to look the same.

———◆———

The end of August is damp. Summer skies, chiselled with rain. This is not unusual, it's wonderfully predictable in fact for a Welsh summer to grandly announce its end in this way: unrelenting downpours turning roads to rivers. My sister's and dad's birthdays both fall in the last week of the month, and at least one of these days is generally spent extremely windswept and drenched along a stretch of the Ynys Môn coastline. Picnics are unpacked and eaten in the car, with flasks of tea decanted into tin cups, steaming up the windows. Birthday cakes are baked and eaten over the course of a week, their tops decorated with borage flowers and, if they are ripe enough, a few small autumn raspberries.

It's around this time each year that we get the last delivery of logs before the winter, a trailer-load emptied out onto the driveway in a great heap. There is a break in the rain when they arrive, thankfully, and we spend the afternoon ferrying them to the woodshed. The damp earthy smell reminds me that we're on the cusp of a new season, and the fresh honeycomb of logs slowly pushes the vat outside of the shelter of the shed. It is a sign of the coming cold and foretells of a change to our summer dyeing rituals that had been made

possible by the warm days. However, a plan exists for the autumn and in the last few weeks of outdoor dyeing, it's set into motion.

———◆———

One clear morning, when the clouds seem to be hovering far enough away that we risk a final dyeing day, Mum carries an armful of wool down from her studio. It is twisted into pale hanks, which she tips into a wide enamel bowl and covers with water to soak whilst we eat breakfast. She is preparing for the approaching cold, and dyeing wool to knit with over the winter.

It is not the easiest material we've submerged in the blue-green vat; the tidy hanks somehow tangle themselves and we have to maintain a tight grip on them or they sink to the sludgy bottom, lost forever. However, the process feels somehow even more precious, as we both know that our days outside are now numbered. My mum keeps track of how many times each length of wool has been immersed and once they are rinsed and dried, she winds them into balls and attaches a small hand-written label to each, denoting the number of dips.

I watch as she moves surely through every step of the process, masterfully achieving exactly what it was she'd set out to do. Over the course of these months at home,

I have witnessed a slow process of growth, such as she must have noticed in me over the course of many summers before. The transformed wool sits neatly in a woven basket, its deep blue peacefully awaiting September.

———◆———

After spending time at the indigo farm in Fujino, my mother took a train north towards Nagano and then to a village called Miasa, in the Japanese Alps, to stay with a friend she had met on her first visit to Japan. Whilst there, she visited a couple who ran an atelier in the village selling naturally dyed fabrics and clothing.

She arrived at the dyehouse in the morning and was greeted by the couple who run the studio, Tazawa and Maika. A fire had been lit in a tiled stove and a deep, wide-mouthed pan filled with water had been placed atop one of the two hotplates, gently coming to a boil. Around the studio, there were boxes and trays filled with onion skins, alder cones, pomegranate skins, logwood bark and marigolds, all waiting to be used to colour cloth.

They dyed with onion skins and alder. Tazawa told my mum that in the winter, they used the height of the snow to reach the higher branches of alder trees in order to gather the tiny black alder cones unreachable

in other seasons, wearing lightweight ski boots to walk across the thick snow. Over the course of the morning, they introduced her to a new way of resist-dyeing cloth using a clamping technique different to the *katazome* and *shibori* resists she'd learnt at the farmhouse in Fujino. Instead of applying a rice paste or stitching to resist the dye, they clamped oblong formers[10] to folded cloth. The pressure applied by the clamps prevented dye from reaching the areas of cloth directly beneath the former, producing steady patterns along the fabric once they were unfolded at the end. They also showed her how to modify the natural colours of the dyestuffs, using iron to darken or copper to add a greenish tint.

The handkerchief-sized clamped pieces of cloth were submerged into the dye baths and left soaking in the murky liquids over lunch. Afterwards, pieces of dark gold and blueish grey were fished out of the now cooled pans and hung outside in the sunshine, their colours lightening as they dried. The onion skins produced yellows and oranges bright as marigolds. The alder cones had turned the cloth a stormy blue, like clouds before snow. They fluttered colourfully in the breeze and my mum sat on the step of the studio, drawing the plants in their garden as they waited for them to dry completely.

10 Pieces of wood used to form resist sections in the dyeing process.

———◆———

Autumn always feels a little hectic. Even once back-to-school days are in the past, the constant changes in weather, environment and daylight leave me feeling as if everything is too busy to ever really settle. The trees burst into flames and their leaves tumble to the ground so quickly, that the season is whisked away in a blur of orange and gold, the charcoal sulk of winter at its edges.

Then, the dampening woodlands and fields sink into their annual slumber, bare and grey without the obvious scurrying of life across their landscapes. In this fallow period, between December and March, hibernation can take place and the yellow crackle of gorse remains a rare reminder that summer's brilliance will return in time.

Over the winter my mum begins working with other natural dyes, kitchen-scale work that fills the house with a damp iron mist on frosty mornings. A tall aluminium preserving pan is set to ceaselessly bubble on the stove, emitting a haze of strange-smelling steam. Each week, something different simmers inside the pot: garlic skins for pale grey-pinks; onions for ochres and browns; alder cones for the colours of storm-laden skies; walnuts for earthy umber tones; and pomegranate skins with iron for deep purple-greys the colour of Bethesda roof tiles.

Slowly, she will begin to build a broader colour palette of cloth. There won't be a particular plan for these dyed scraps of fabric, she'll be motivated purely by the enjoyment of witnessing the transformation of cloth made possible by natural dyeing. Like the seed packets and labels which became canvases for drawings, she'll collect them into bundles and store them until it's the right time to use them.

These cold-weathered dyeing practices will become extensions of our food foraging, they'll became a new way of knowing our geography. There is a thrill in realising that behind the colours we see on our walks each day, there is an entire spectrum hidden from view. The dark brown cones of a larch somehow producing subtle charcoals and the deep purple of elderberries turning cloth a sweet pink. The process holds an undeniable proximity to magic, like the glow of sunlight haloing clouds after a storm, or moonlight strong enough to fall in silver ribbons through a window – bestowing a sense of subtle yet profound awe.

The process is a new addition to our winter rituals that stave off depression and combat the lack of inspiration that tends to seep in with the early evenings. We arm ourselves with knitting, the same morning ritual that had produced my unworn black-Shetland scarf from the year previous. In this time books are read,

steamed puddings and crumbles baked, slow suppers cooked and sloe gin turned from clear liquid to deepest magenta. Small drawings are made as offerings to suddenly arising ideas of not-wasted time but really, we allow our bodies and minds to slow to a crawl, and occupy our hands – and subsequently our minds – with jumpers, cardigans, tank tops and scarves. These are different kinds of making, winter kinds of making. They are the counterparts and continuations of our artistic practice, essential for survival.

I now realise that her months of slow creative output, of momentary refocusing on other creative tasks, are in fact a vital dimension of my mum's artistic practice. An annual moment of repose, in which thoughts are allowed to rest, to be reconsidered.

These are all parts of the long and complex process of creativity I witnessed over the summer months. There are many elements that slip into the background of one's work once the final piece is complete and they remain, too often perhaps, entirely overlooked. It is easy to forget how many incomplete pieces preclude the finished work. The hours spent dipping pieces of fabric, sometimes in torrential rain, others in the sweltering midday sun; the constant reconfiguration of recipes and working methods as you negotiate the terrain of a new technique; the periods of time in

which you cannot work, either because of the weather or because of creative block.

Over time, I've come to embrace creative block as my mind letting me know it's time to step back – to slow down and focus on something else for a while. Perhaps another way of seeing this 'block' is as a process of gaining or seeking perspective rather than curtailing something we're impatient to achieve. It's an inevitable part of creativity, and so to rebel against it would be futile. Instead, you have to allow it to move on of its own accord. In these times, my mum takes long walks, spends time in the garden, follows recipes for meals she's long intended to make. It is a period in which we can dedicate time to other things and prioritise our routines differently. These intervals in normal working patterns can last hours, days, sometimes entire seasons, until one day I enter the kitchen and find my mum drawing once more at the table; a peaceful equilibrium of work and life restored.

My mum is an artist, but she is also a cook, a knitter, a walker, a swimmer, and I'm all of these things too. They are the coping mechanisms she passed down for every foreseeable disaster. I watch as she looks to these exact same coping mechanisms over the course of the summer and realise that just as I had returned home for a year in order to process the loss of my grandfather

alongside my mum, I have migrated back to her in order that she could now do the same. I had no idea how to help her move from a period of mourning into one of recovery, but there was a certain strength in just being with one another.

———————— ◆ ————————

The summer began with simply dyed lengths of linen and ended in pieces of dark wool holding patchworks of line-drawn florae upon them. Perhaps we too often consider artworks as finished articles when in reality they are the result of months and years of change and development. My mother's work is just as much indebted to her time spent walking, cooking, gathering and knitting as it is to the physical acts of dyeing cloth and drawing with ink.

The summer of indigo calls my attention to the invisible threads between artists' everyday life and work. I find myself confronted with a recognition of something I had quietly long understood but had never really acknowledged: that without making, without creative practices, healing is far more difficult – perhaps impossible. Watching my mum working through her grief, soaking cloth until it was the deepest oceanic blue, reminded me of the ways in which the unsaid can

be explored through art; that through making we can convey that which is difficult to say in words. Over the course of the summer, which slipped past in a blur of indigo, I witnessed the indispensable roles art, creativity and nature have to play in our everyday lives.

———— ♦ ————

Our village, with its familiar walking and foraging routes, is the landscape in which both myself and my mother are completely comfortable, completely ourselves. It's necessary to travel away every so often, but I doubt that either of us could ever permanently leave rural existence entirely behind. This way of living is an integral part of who we are and how we process the pressures of daily life. Without a forest walk every once in a while, my mind is quickly overtaken by a whirring chaos of anxiety, a suffocating tension that crawls into my bones. I need to be able to spend summer evenings watching the sun set below the opposite hill, its light catching clouds of mosquitos interrupted by the hungry dives of sleek swallows. This is where I find the joy to work, study, write, paint and travel – in these quiet moments of serenity to be found at home in Wales.

———— ♦ ————

My mother's most recent collection is handmade, composed of hundreds of pieces of hand-dyed cloth. Some are deep black, others the faintest eggshell. There are linen tablecloths with tidy edges and roughly cut fragments of wool resist-dyed with botanical drawings. It is a collection that speaks to a process of mourning, in which pieces of wool stitched into blankets convey a need for comfort, and their botanical patinas become hopeful symbols of the inevitability of regrowth and recovery.

She will not keep every single piece. One day she'll decide to sort through the swathes of fabric and select those she finds most inspiring for further thoughts and articulations. But, for the time being, she will hold onto almost every single fragment of the precious indigo-dyed fabric that covers our living room floor and steeps our garden in blue, like a great summer flood.

Further Reading

R. S. Thomas, *Selected Poems* (London: Penguin, 2004)

Jenny Balfour-Paul, *Indigo: Egyptian Mummies to Blue Jeans,* (London: British Museum Press, 2011)

Tove Jansson, *The Summer Book* (London: G.K. Hall, 1977)

Catherine E. McKinley, *Indigo: In Search of the Color That Seduced the World* (New York & London: Bloomsbury, 2011)

Yoshifumi Miyazaki, *Shinrin-yoku: The Japanese Way of Forest Bathing for Health and Relaxation* (London: Aster, 2018)

Karen Patterson, *Lenore Tawney: Mirror of the Universe* (Sheboygan, Wisconsin: University of Chicago Press, 2019)

James Rebanks, *English Pastoral* (London: Penguin, 2020)

Yoshiko Iwamoto Wada and Mary Kellogg Rice, *Shibori* (Tokyo: Kodansha, 2012)

Acknowledgements

To my mum, dad and sister – you three keep me grounded and entirely happy.

To Amy Feldman, whose thoughtful editing and guidance brought this book into reality. Abbie Headon, Maria Vassilopoulous, Elin Williams, Ruth Killick and Amy Stewart for their kind words, hard work and care. Claudia Rutherford, who encouraged me to write and published it, article after article. And, Jenny, for her friendship and the use of a garden studio, which often saved me in times of writer's block.

To the staff of the British Library and its reading rooms, without whom the research and writing of this book would have been infinitely more difficult and far less enjoyable. Also, to Jenny Balfour-Paul for her wonderful books on indigo, which kept me company through the winter months. Pophams deserve a mention here, too, for keeping me in caffeine and in good company along the journey.

To the friends I met in that small coastal corner of Fife – you gave me the courage to write.

Thank you, thank you!